INDIANA BARNS

QUARRY BOOKS

AN IMPRINT OF

INDIANA UNIVERSITY PRESS · BLOOMINGTON · INDIANAPOLIS

INDIANA BARNS

MARSHA WILLIAMSON MOHR

Introduction by Duncan Campbell

This book is a publication of

Quarry Books
an imprint of
Indiana University Press
Office of Scholarly Publishing
Herman B Wells Library 350
1320 East 10th Street
Bloomington, Indiana 47405 USA

iupress.indiana.edu

First paperback edition 2015
© 2010 by Marsha Williamson Mohr

This book is printed on acid-free paper.

Manufactured in China

The Library of Congress cataloged the original
edition as follows:

Mohr, Marsha Williamson.
 Indiana barns / Marsha Williamson Mohr ;
introduction by Duncan Campbell.
 p. cm.
 ISBN 978-0-253-35568-3 (cloth : alk. paper)
1. Barns—Indiana—Pictorial works. I. Title.
 NA8230.M63 2010
 728'.92209772—dc22
 2010021171
ISBN 978-0-253-01521-1 (pbk.)
ISBN 978-0-253-00169-6 (eb.)

2 3 4 5 20 19 18 17 16 15

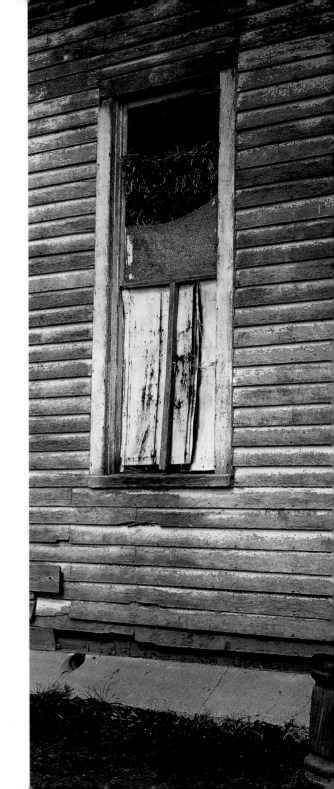

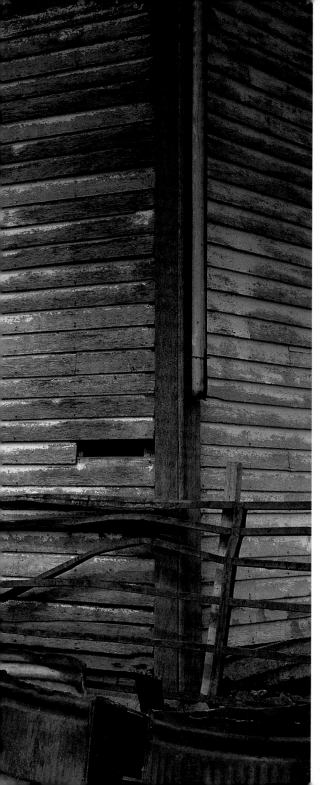

When Marsha (our talented daughter) asked me if I would write something for her latest book, I quickly accepted her offer. You see, I was born and raised in the era of the big barns, and so many good things in my life centered around that massive barn back home....

But let's go back even earlier. The very first barns in Indiana were rudimentary log structures, more suitable to protecting feed and provender from wild animals than to housing the domestic variety. Those early barns weren't made for animal shelter. The pioneer's livestock, which was branded to protect their owner's property, roamed the woods and scavenged for food. Roundup time in a virgin Indiana woods must have been a thrill to see!

When water-powered sawmills came to the local rivers, sawn lumber became available and pin-frame barns with cut siding and partitions became common for animal housing. These were the first really large barns in Indiana. Later, English-style barns were built on level ground and German-style bank barns on hilly land, which were great for large quantities of hay on the first (upper) floor and for housing livestock on the lower level. Most of the early barns went unpainted. Such farms had a windmill for water, and sometimes a wooden silo. A few of these farms still exist today.

The truly "golden age" of the Midwestern farm was from 1890 until the scourge of the 1920s depression. Better building materials were available by then. A slate roof with one's farm name inscribed on it was available for the proud and stone foundations were common. A typical barn of that day could hold sixty tons of red clover hay, a few hundred bushels of corn and oats, stalls for a few brood sows, several cattle stalls, half a dozen cow stanchions, and stalls for around six horses. A silo stored corn ensilage for

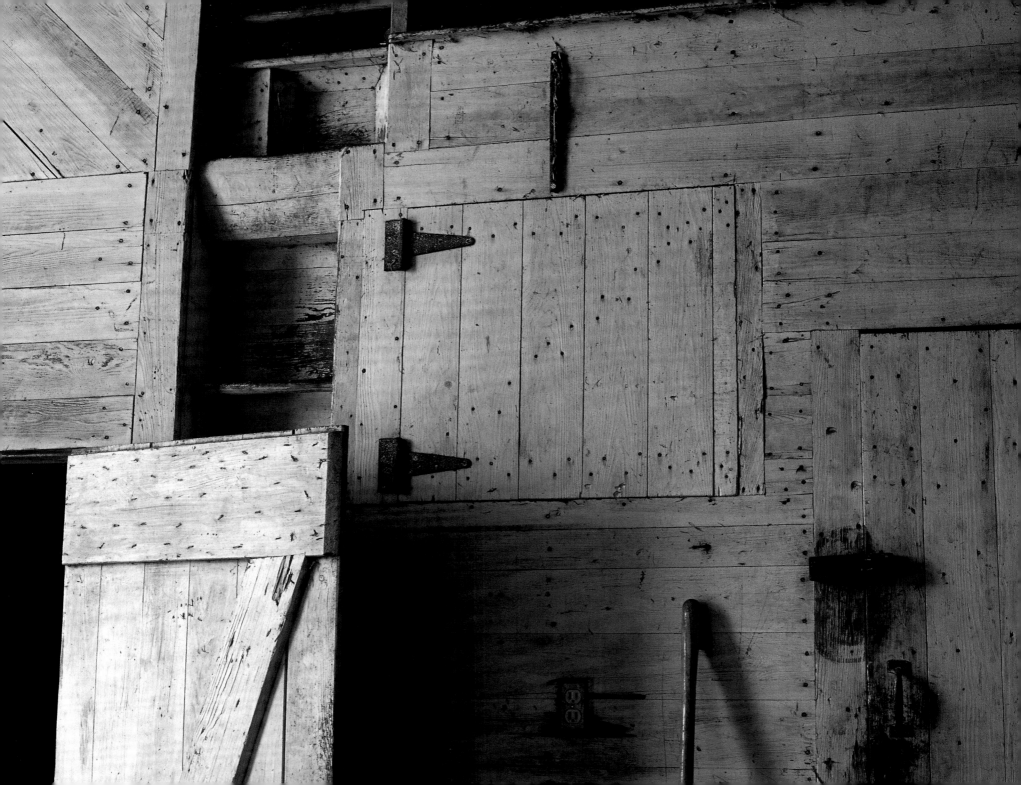

the cattle. The barn roof might have had ornate ventilators as well as weather vanes and lightning rods. Our barn was painted white, but more often the ones from that era were red with the window frames painted white. The farm name, or the owner's name, was painted over the main door along with the date that the barn was built.

The barn of course did not stand alone. A typical farm of that time had many out-buildings, among them a hen house, a portable brooder chicken house, a farrowing barn for hogs, and possibly a corn crib, smoke house, outhouse, and wash house.

For many years, I traveled for Purdue University all around Indiana and I always wel-comed the opportunities I had to just travel cross country, looking at barns, livestock, and crops, the way we did on Sunday afternoons in my childhood. Many old farm-steads still remain, but they have suffered from changes in farming practices. Farms are generally much larger these days, production is very specialized, and most barn doors aren't wide enough to get a modern farm implement through them.

To see these barns slowly moldering away somehow deprives us of a little bit of our lives. To sit in the old barn, listening to the wind whistle through the cracks in the sid-ing, or to hear the cooing of the pigeons or the hooting of the barn owls is a reminder of earlier great times.

I don't have any great knowledge about barns or their architecture, but I can remi-nisce about how delightful it is to cuddle up beside an old milk cow on a cold winter day, or smell new red clover hay, or find a new nest of kittens, or swing over the drive-way on the hay rope.

Those joys may not be available anymore, but the remembrance of them through this book is sufficient reason for its publication. I'm delighted our wonderful daughter, Marsha, decided to do this barn book.

Maurice L. Williamson

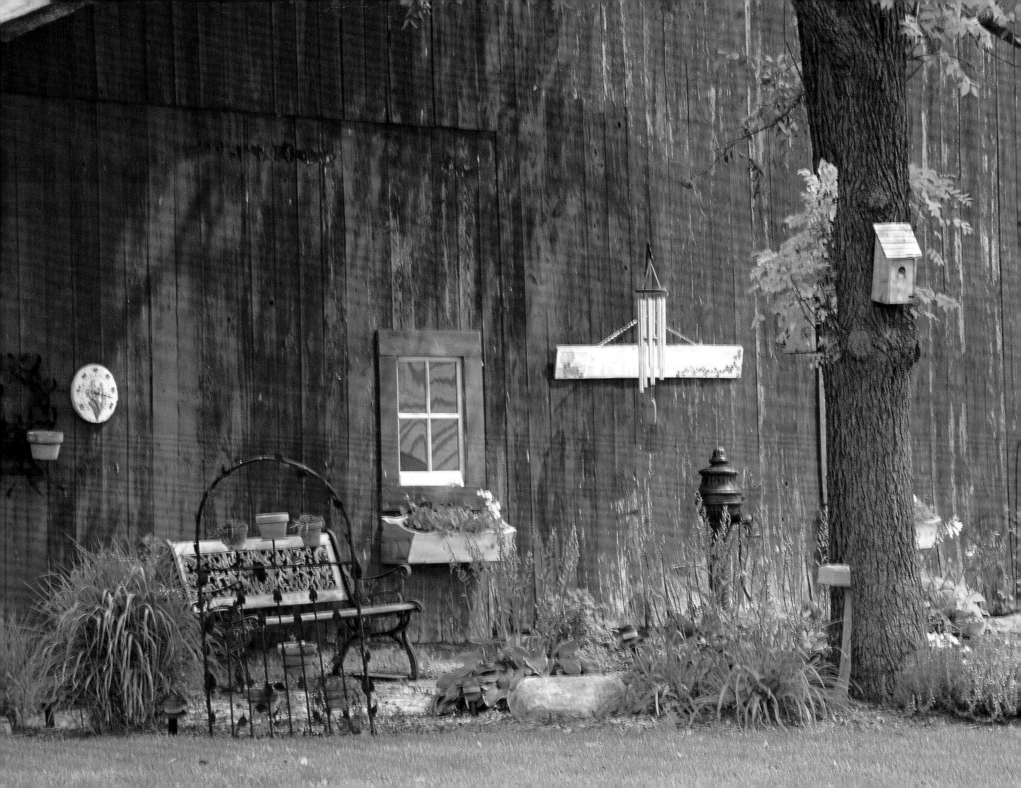

C O N T E N T S

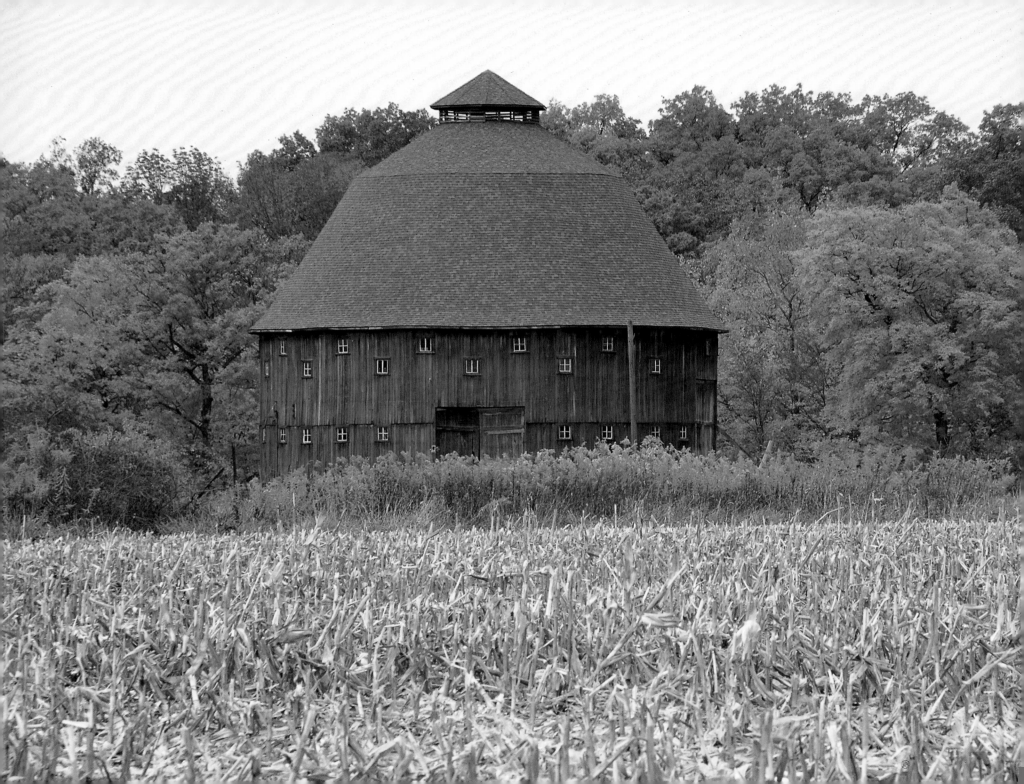

ACKNOWLEDGMENTS

I want to salute my parents, June and Mauri Williamson, for this book's highly regarded subject, Indiana barns. As a child, I may not have been the most attentive of the work my father did for agriculture, I just missed his presence at home. But his appreciation for those roots, the history, the love of rural life, the love of working the land did get my attention. When we were together, his presence was greatly treasured. Dad taught me how to love nature, and to love the rural countryside. In the summer of 1964 our family traveled 8,000 miles in one month, seeing everything from the Lincoln Memorial in Illinois to the Pacific Ocean. This vacation is what inspired me to be a photographer and those vacation photos enabled me to win a blue ribbon at the 4-H fair that summer.

Since then, my parents have traveled long distances with me shooting photographs. Mom was with me while I was photographing many of the 92 covered bridges for my book *The Quiet Path: Covered Bridges of Indiana.* Dad very carefully put in writing the astonishing narrative. Dad and Mom take pains to do such script. First in pencil, second on his typewriter, third with Mom on the computer, and fourth transferred to my computer for publication. *The Quiet Path* was one of the first of many projects we have done collectively.

Not to be forgotten is my dear husband, Larry. Not only traveling with me and putting up with long exposures, waiting for perfect lighting, setting up the tripod while out photographing the countryside, but he has put up with doing laundry, grocery shopping, cleaning the house, and with being alone so I am able to spend so much time doing what I love so much.

Now, even in my absence, when Mom and Dad are traveling through the countryside and see a barn, they call out to each other, "That's a Marsha barn."

MWM

To my graduate assistant, Beth Bjorklund, for her research into barn typologies and technical nomenclature, and for her assistance with photo selections and captions, I offer my thanks.

DC

INDIANA BARNS

INTRODUCTION

Duncan Campbell

Few stories so well represent the history of our continent's settlement as the story of the American barn. Our barns are relatively plain buildings, but theirs is not a simple narrative, for they relate an intricate chronicle of the American agricultural experience. As a symbol of this story, the barn is as complex and varied as the tale itself, the wide-ranging result of the many influences brought to the American landscape by those who settled it. Indiana's barns are no exception, and Marsha Mohr's photographs bring a particularly satisfying display of this American icon to those familiar with the special landscapes of the state of Indiana.

Though its history has many layers, the physical simplicity of the barn is an important part of its aesthetic. It is often large, and constructed of massive timbers. Set out on the land, barns can be rather plain in aspect, combining wood and stone, often unpainted and weathered; or if painted, usually black or brown or red or white, and fading. When adorned, it is commonly with dated advertising that itself has become a convention of the roadside landscape. And too commonly, it is sadly sagging, its roofline broken, siding a sieve for sunlight or snow—a remnant, a reminder of a time and place that few people today can claim as theirs.

For me this brings a mythic quality to our barns, an implied romance written on the land by a way of life shrunk to insignificance in an altered and neglectful present. Barns speak of ethnic specialty, and relate in their designs the origins and folkways of those who brought their traditions to America in the search for another, better life. In the same breath, American barns reflect the settler's response to the requirements and resources of a new homeland where terrain, available materials, changing husbandry, and the individual's skills and traditions mixed with those of his neighbors to reshape the barn. So the barn as we experience it today reflects the bygone traditions brought from the many countries of our origin, but is also a statement of adaptation, change, and survival in a new land—the stuff of myth.

The local barn, then, tells this story as it happened in Indiana, and is illustrated in this book by many of the most customary American barn typologies found across the country. The locations of barn types can indicate who traveled the settlement routes taken into that area, and whether they came across Virginia and up from the south, or down the Ohio River and on into the middle counties, whether across Pennsylvania and mid-Ohio into the eastern regions, or from the northeast and New York into the northern reaches of the state. Although the Indiana settler almost certainly used one of these common routes, once here his movements are less predictable; but regardless of the route taken, the barn left behind marks the locus of his activity and is the telltale of his origins, traditions, skills, and the builder's response to the region's bounty—trees, stone, or clay for bricks. Among the most common barns found in Indiana are the English barns, brought to America by English colonists, the Transverse Frame barns, probably of German origin, and the Pennsylvania barns, also from the German tradition. A later form, the round or polygonal barn of nineteenth-century derivation, most common in the Midwest,

and Indiana in particular, is also beautifully illustrated in these pages, as are a few other less common forms.

Barns from many origins have been documented across the United States, including French barns, Dutch barns, and others, but those represented here, and most commonly seen in Indiana, are primarily derivatives of the Transverse Frame, English, and Pennsylvania types. Some appear in their relatively pure forms, but numerous variations result from later additions acquired by changes in purpose, fresh farm practices and technology, the cultural influences of subsequent users, or the expansion of the particular farming operation itself. Often the barns pictured in this book have been enlarged with shed additions to accommodate tractors and other mechanical equipment for which they were not originally conceived. Other variations occur within a single style attribution, and may include very early forms. For example, it is not unusual to see an English barn constructed into a hillside as a bank barn with provision for livestock below, even though this style is thought to originate with the English Three-Bay or Threshing barn,*originally intended just for crop storage and threshing, and not built into the slope, nor intended to house animals. Similarly, there are countless regional variations of other barns of known origin, an indication of the richness of our own heritage and the complex nature of our settlement patterns. These alterations are an important part of the barn's testament.

If recognizing barns by their source and architectural form is complicated by the variety of adaptations, identification is aided by additional proofs, many of which can point back to the barn's form, culture of origin, or time period. One of these is the means of construction. Though fewer and fewer remain, many early American barns and agricultural outbuildings were constructed of logs, a fairly quick

*Allen G. Noble and Richard K. Cleek, *The Old Barn Book: A Field Guide to North American Barns & Other Farm Structures* (New Brunswick, N.J.: Rutgers University Press, 1997), 79.

and simple method of construction where trees were available. The techniques by which the logs were joined are indicative of the skills and traditions of the builders. Scandinavians, Germans, and the English are among the European settlers who brought familiarity with these skills to America. Similarly, there are many fine examples of hand-hewn timber frame barns in Indiana, which were constructed well into the nineteenth century in the Midwest, and for which highly specialized skills were needed to lay out and assemble the complex puzzle of properly fitted joinery. These skills continued to endure into the twentieth century using sawn timbers. It is not uncommon today to see timber barns with both hewn and sawn timbers in use, indicating perhaps the overlap of technologies on the one hand, and the longevity of use on the other, as deteriorated hewn timbers were replaced with sawn, or timbers from older barns were reused in new ones. In all cases, timber frame and log barns were common to areas where mature trees were readily available and in close or immediate proximity to the building site, and where the requisite skills were available. In Indiana, the tree of choice was the virgin Tulip or Yellow Poplar, preferred for the length and straightness of its trunk, lightness and workability of its wood, and resistance to insects.

Barn origins can also be identified through a number of other means, where certain traditional patterns of design were consistently maintained, even if other, more secondary attributes were not. The patterns that are used to define and describe barn configurations include the barn's roof type (gable), entry location (gable end), floor plan (three-bay), intended crop storage (hay barn) or animal use (dairy barn), and peculiarities of shape and construction (extended gable, fore bay). As an example: The English barn in its purest form is timber framed, has a single gable roof over a single story, few if any windows, and a slightly rectangular plan featuring

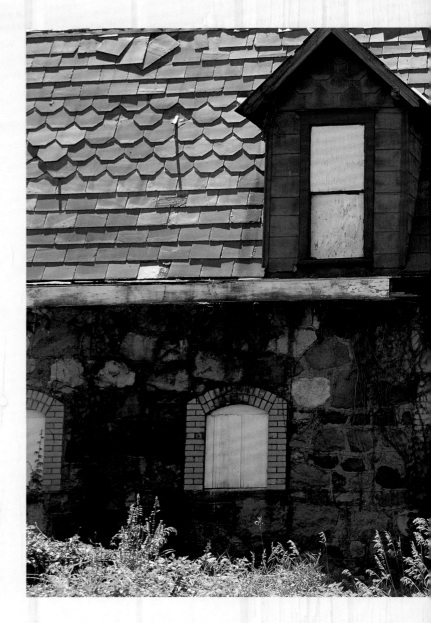

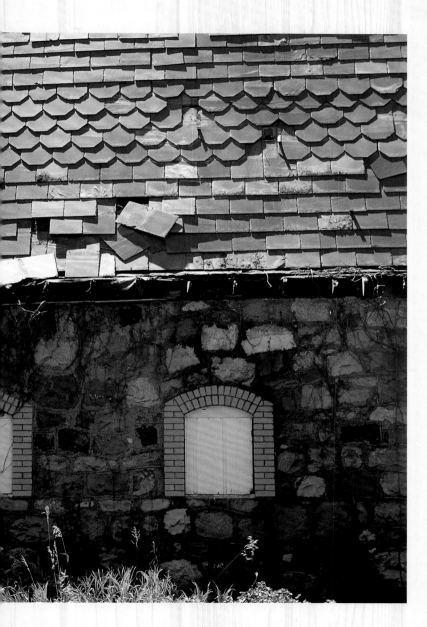

three interior bays or cribs. The design was intended primarily for grain and crop storage, with the through bay for use as a threshing floor. The wagon doors are centered on the eave sides, and the threshing floor forms the central bay.

Roof styles on Indiana barns most commonly include the simple gable and broken gable, the gambrel, the round or gothic, and the shed or pent roof. There are variations of pitch for each roof configuration, and occasionally combinations or intersections of more than one type, as well as appendages such as gable or shed-roofed dormers, hay-hood projections of a variety of shapes, and roof-mounted mechanical ventilators or cupola ventilators to promote air movement. The material covering the roof is of course vulnerable to the weather, and expected to deteriorate over time. Consequently, extant material is rarely original to the structure. Exceptions can include slate, which can last a hundred years, but most barns never received such expensive applications. More typical roof coverings are wood plank, sawn wood shingles, or split wood shakes, later replaced by slate, standing seam or corrugated metal, and asphalt or fiberglass shingles.

The location of the primary entry refers to the placement of the barn's wagon doors, the largest point of entry into the barn, located either on the gable end or the eave side of the barn. In the Transverse Frame barn and Dutch barn, these doors are located on the gable end, and lead into a centrally located aisle that runs with the roof ridge, while in the English and Pennsylvania barns they occur on the eave side of the building, entering an aisle that runs at right angles to the roof ridge. Additional large openings are often seen in shed additions built along the sides or on the ends of older barns, constructed to provide space for tractors and other farm machinery, shop space, or other uses. A barn's relationship to the terrain is another way of describing its configuration, whether it is built into a slope or raised

on a masonry basement, as is its size and shape, the placement of window openings, siding orientation, or the frequency and location of its ventilation devices.

Dating the Indiana barn is not easy, for written documentation is scarce, but there are construction and finish details, as well as stylistic or period flourishes that can be helpful. One problem with establishing a construction period has been discussed—most barns have been continuously repaired, renewed, and reconstructed as long as someone had a use for them. These alterations include major additions to the structure as well as demolitions, so the more one knows about the early barn configurations, the evolution of materials, and agricultural applications, the better equipped he or she is to accurately place the barn in its historical period. Most Indiana barns constructed before World War I are timber frame construction, and the earliest are log or hewn timber. It would be extremely unlikely to find a barn in Indiana built before 1800, and rare to encounter one constructed prior to the Civil War. After 1870, most are built from sawn, dimensional lumber, although the main frame may be timber. The earliest rafters are often cut poles measuring from three to five inches in diameter and approximately twelve to fourteen feet in length, arranged in multiple runs as the roof required. Subsequent rafters are hewn or sawn dimensional lumber. The timber frame, with its top and sill plates, and intermediate girts, all horizontal members, was an ideal configuration for attaching vertical wood plank siding, which is the siding configuration most commonly seen. Usually rough sawn, these planks were often covered at their longitudinal edges by narrow wood battens, which reduced wind and rain penetration; on more finished barns, particularly those of later construction or with replacement siding, the planks were often milled with a shiplap or other fitted joint that enabled the planks to seat against one another in a manner providing a more weather resistant skin.

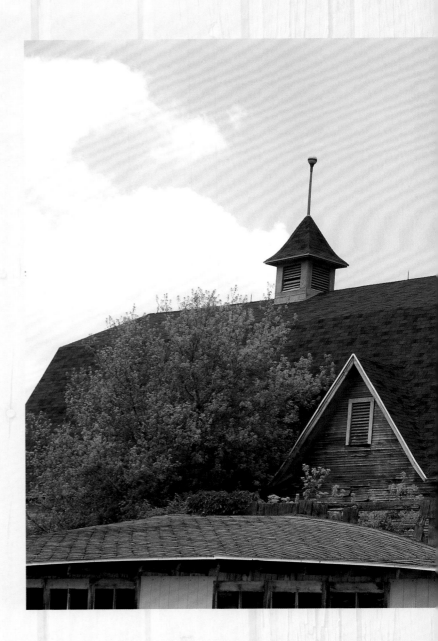

Most rough sawn planks bear the curved marks of the circular saw, which came into use in sawmills after 1845. Rough sawn planks bearing vertical saw marks oriented across the plank were almost certainly sawn on vertically operating (reciprocating, water powered) saws that preceded the circular blade. This is an important telltale and can be readily determined in most barns constructed from wood by close inspection of the siding or interior planks. Vertically operating saws were relatively slow and many mills did not have carriages capable of handling logs of the length needed for barns, so vertically sawn timbers are less common. Consequently, hand hewing continued throughout the period of transition from one sawmill operation to another, and regional differences obtain, making it difficult to accurately date many barns or determine when one technique left off and the other began. For this reason it is possible to encounter hand-hewn timbers and original circular-sawn siding on the same barn. Replacement siding can further confound the issue, as can the continued application and even reuse of early types of nails. Therefore, it is important to look for consistency in style, or barn type, as well as in the framing technique, the siding, and the nails, since over the years alterations have brought variations in each.

Stylistic flourishes can also inform the age of a barn, most notably those from the Victorian period—generally from 1870 to 1900. These are seen most often in the decorative details, and in Indiana it is normally safe to say that the only consistent decoration, other than painted advertising and examples of painted door arches and trim details, occurred in the Victorian period. Elsewhere, the Pennsylvania barn is most notable for decorative brickwork and painted decorative insignia, the so-called hex signs. And barns constructed of ceramic block have color as decorative accent. In these pages, look for the stylistic differences in the ventilator

cupolas in particular, variety in wood-shingle siding and window trim, or occasional decorative spool work similar to that seen on the porches of Victorian homes. It appears that most Indiana farmers may not have had either the money or the inclination to express these taste preferences in their barns, although it should be clear from the photographs that barns were constructed with great care, and were a significant source of pride for their builders. They were, after all, the most important buildings on the farm.

The great misfortune, and acknowledged but largely unwritten chapter, in the story of the American barn, is its gradual banishment from the countryside. Indeed, the disappearance of the rural way of life itself, or at best the transformation of the family farm to the corporate one has to bear some of the responsibility for the loss of these wonderful buildings. Indiana is no exception when it comes to our failure to protect theses icons, although efforts by the Historic Landmarks Foundation of Indiana to acknowledge farm rehabilitation successes, and the National Trust for Historic Preservation's Barn Again program certainly represent strides worth applauding. Moreover, the many individual labors to convert barns to new uses, move them to alternate locations, or reconstruct and rehabilitate them should not go unnoticed, but the reality is that abandonment, and the pressure to redevelop existing rural landscapes with new housing, shopping centers, and highways has long been the enemy of the historic farmstead.

I hope that this book, whose simple but poignant images speak to the beauty and saga of another era, like our barns themselves, will encourage others to recognize the cultural and historic importance of these structures. If we have had, by necessity or choice, to travel across the past century from a land of farmers to one of urban dwellers, and have, to our credit, discovered alternate methods

for feeding others, and ourselves, then it follows that we can find the means to protect our rural story. It is so much more than the story of the buildings; it is our story, who we are and where we come from, what we brought with us and may no longer know. Every time we lose one barn we miss the opportunity to learn, to be reminded, to understand that one, critical part of our rural past. Once that barn is lost, articulating our history, fathoming our achievements, and evaluating our present undertakings become more difficult, until one day there are no barns, and no barn books. But we also lose the experience of the barn itself—the smells, the dark and dusty space, the filtered light, and the chance to open our imagination to the past.

BIBLIOGRAPHY

Arthur, Eric, and Dudley Witney. *The Barn: A Vanishing Landmark in North America*. Greenwich, Conn.: New York Graphic Society, 1972.

Bouland, Heber. *Barns Across America*. St. Joseph, Mich.: American Society of Agricultural Engineers, 1998.

Gianni, Benjamin, Bryan Shiles, and Kevin Kemner. *Dice Thrown*. New York: Princeton Architectural Press, 1989.

Halsted, Byron D., ed. *Barns, Sheds and Outbuildings: Placement, Design and Construction*. Chambersburg, Pa.: Alan C. Hood & Co., 1994.

Narayanan, Bethany. *The Painted Barns of Southeastern Indiana: Decorative Painting and Commercial Advertisement*. Graduate thesis, Ball State University, 2001.

Noble, Allen G., and Richard K. Cleek. *The Old Barn Book: A Field Guide to North American Barns and Other Farm Structures*. New Brunswick, N.J.: Rutgers University Press, 1997.

Noble, Allen G., and Hubert G. H. Wilhelm. *Barns of the Midwest*. Athens: Ohio University Press, 1995.

Rawson, Richard. *Old Barn Press*. New York: Bonanza Books, 1979.

Sloane, Eric. *Eric Sloane's An Age of Barns*. New York: Henry Holt and Co., 1967.

GALLERY

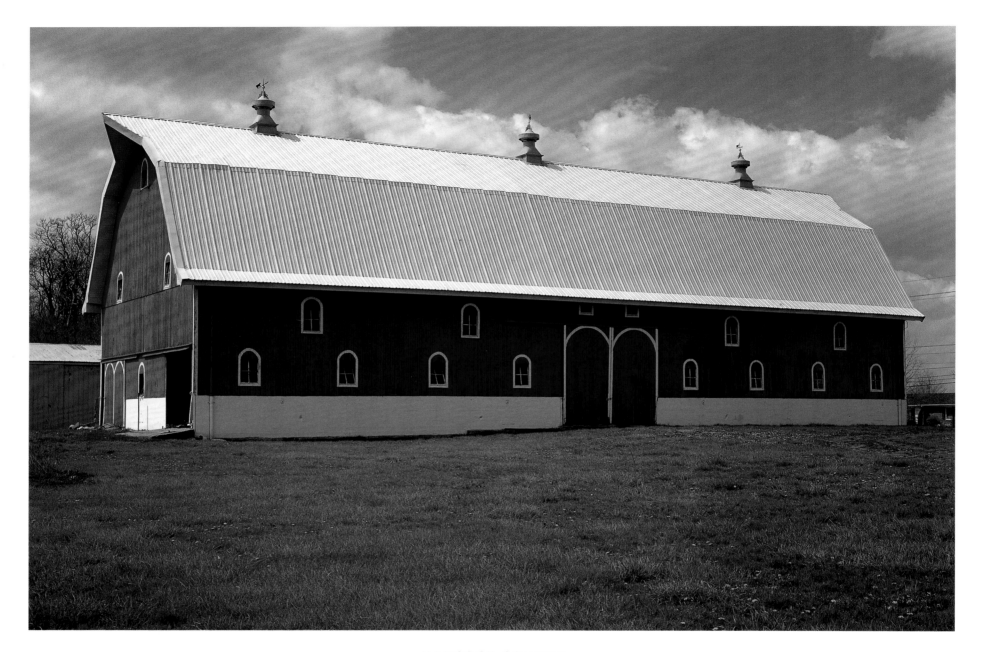

HANCOCK COUNTY

A decorated livestock barn with a gambrel roof and side-aisle
wagon doors, featuring three metal ventilator
cupolas and painted door arches

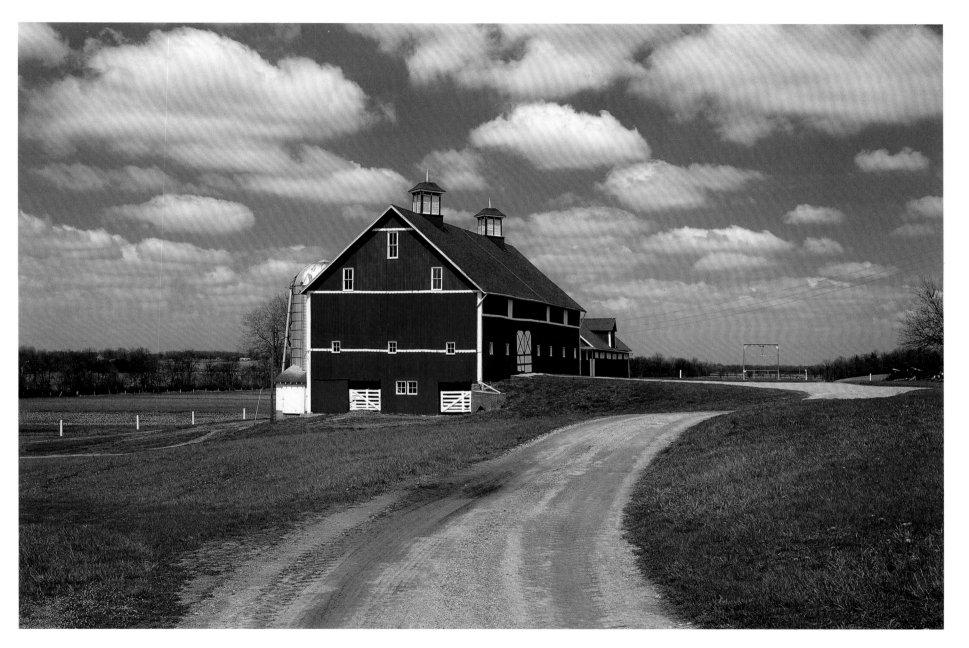

HENRY COUNTY

*A decorated English bank barn with a gable roof and
louvered right-angle ventilator cupolas*

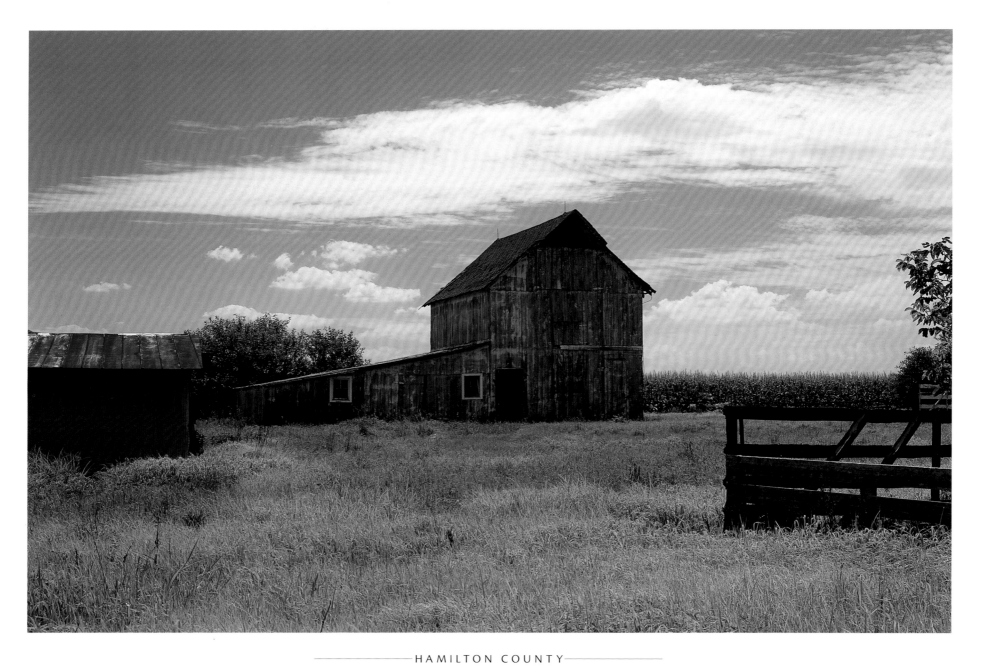

A transverse frame hay barn featuring a gable roof,
hay hood, and a shed-roofed addition

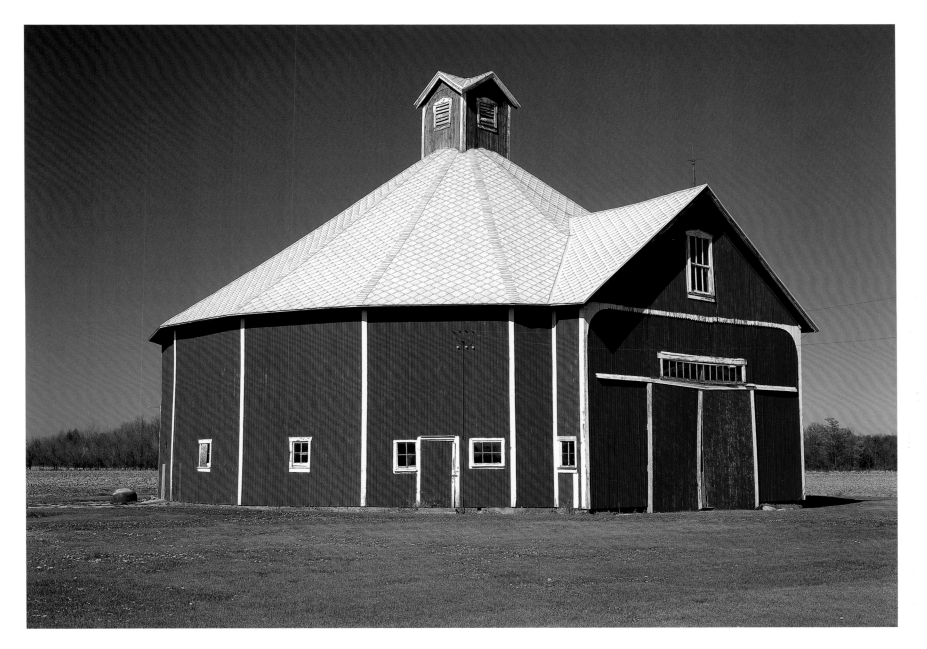

*A polygonal barn with a gabled entry porch, featuring
a ventilator cupola with a cross-gable roof*

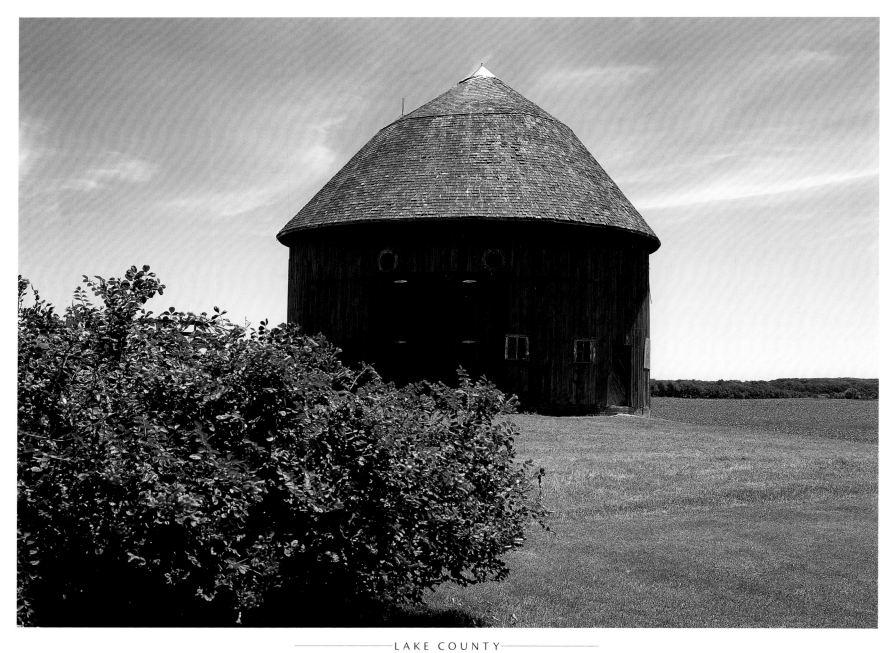

LAKE COUNTY

*A true round barn with a conical roof
and oculus windows*

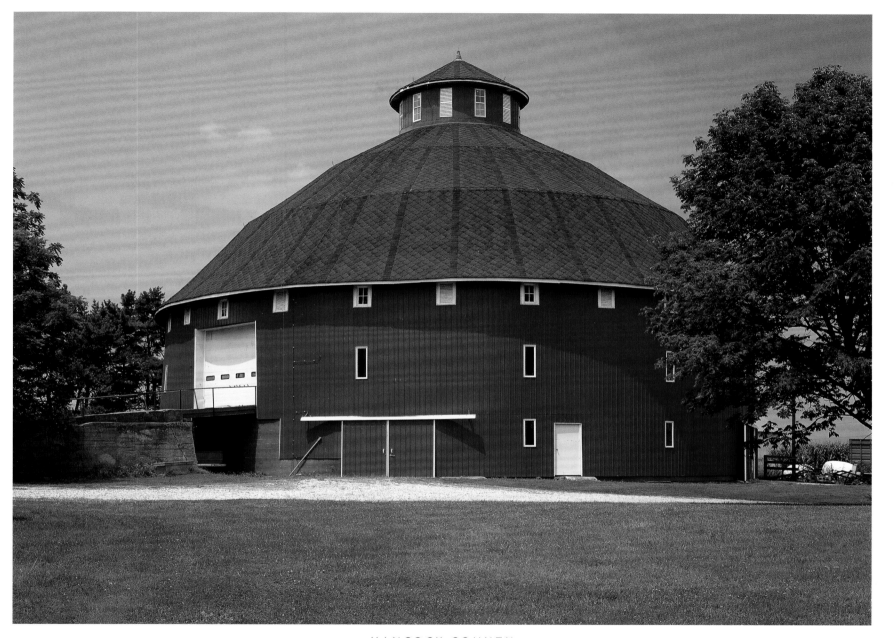

A decorative, round hay and livestock barn with a barn bridge
to the entrance; it features a round ventilator cupola
and decoratively painted windows

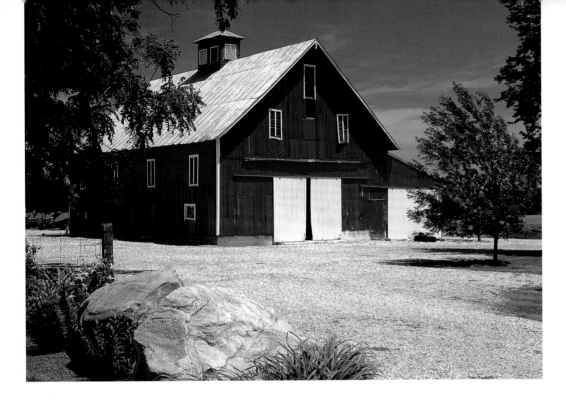

CLINTON COUNTY

A decorated Dutch barn with a gable roof and equipment shed, featuring a ventilator cupola and decoratively painted windows

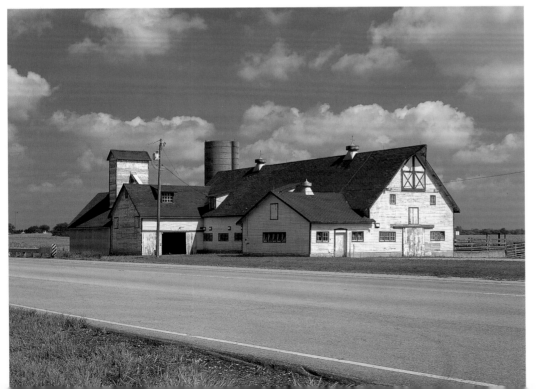

LAKE COUNTY

A gable-roofed hay and livestock barn with multiple gable additions and a granary; it features metal ventilators, dormer windows, and a hay hood

(LEFT)

VIGO COUNTY

A gable-roofed, decorated hay and livestock English barn variation with two cross-aisles

(FACING)

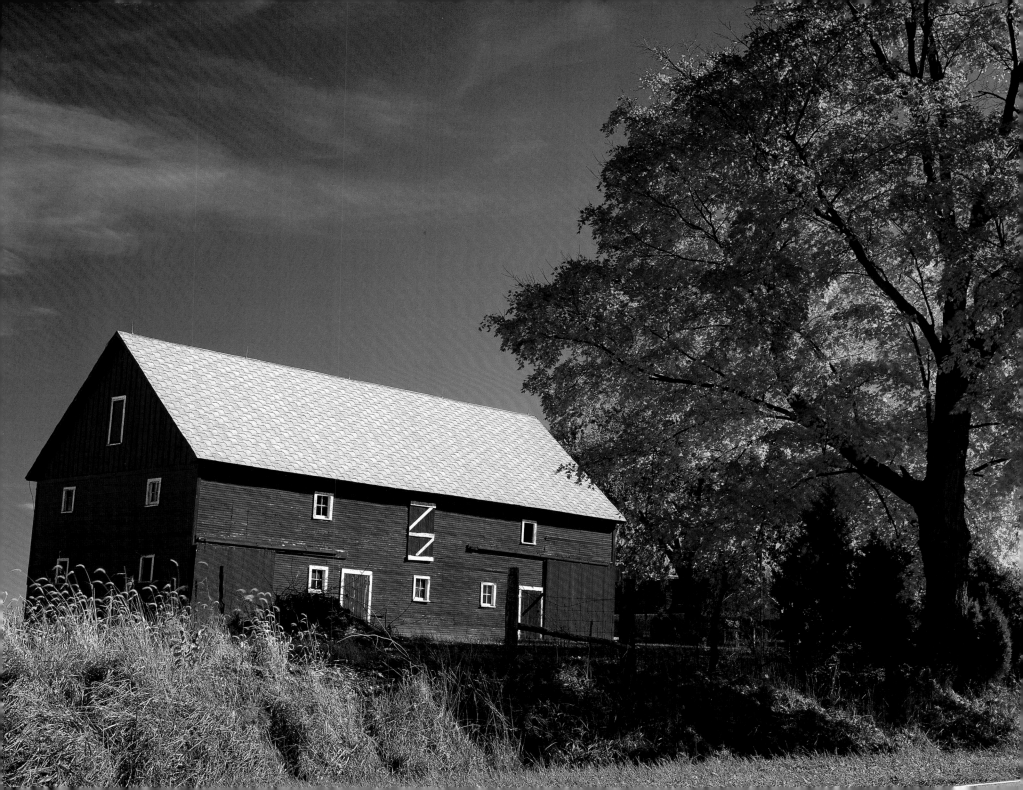

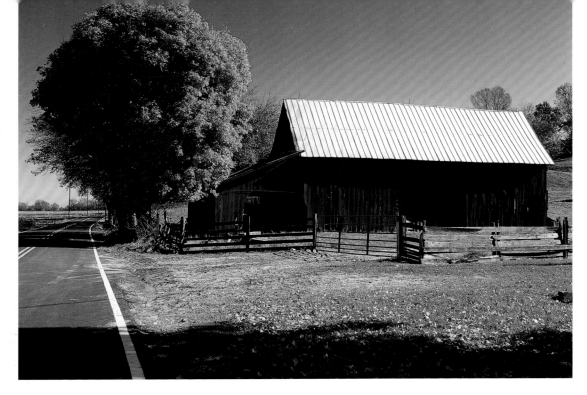

VIGO COUNTY

*A gable-roofed English barn with a
shed-roofed equipment addition*

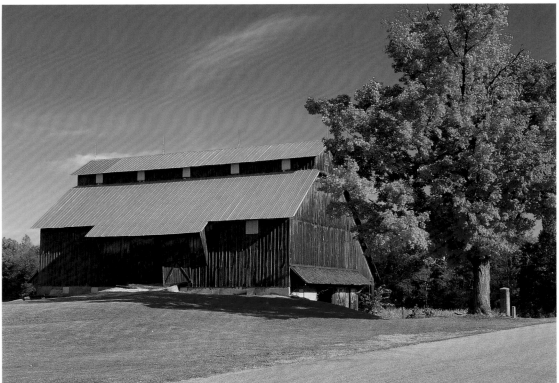

PARKE COUNTY

*An English bank barn with an asymmetrical
monitor roof, featuring a pentice roof
over each entrance*

(LEFT)

FRANKLIN COUNTY

*A gable-roofed Appalachian hay barn
with a banked front cross-aisle*

(FACING)

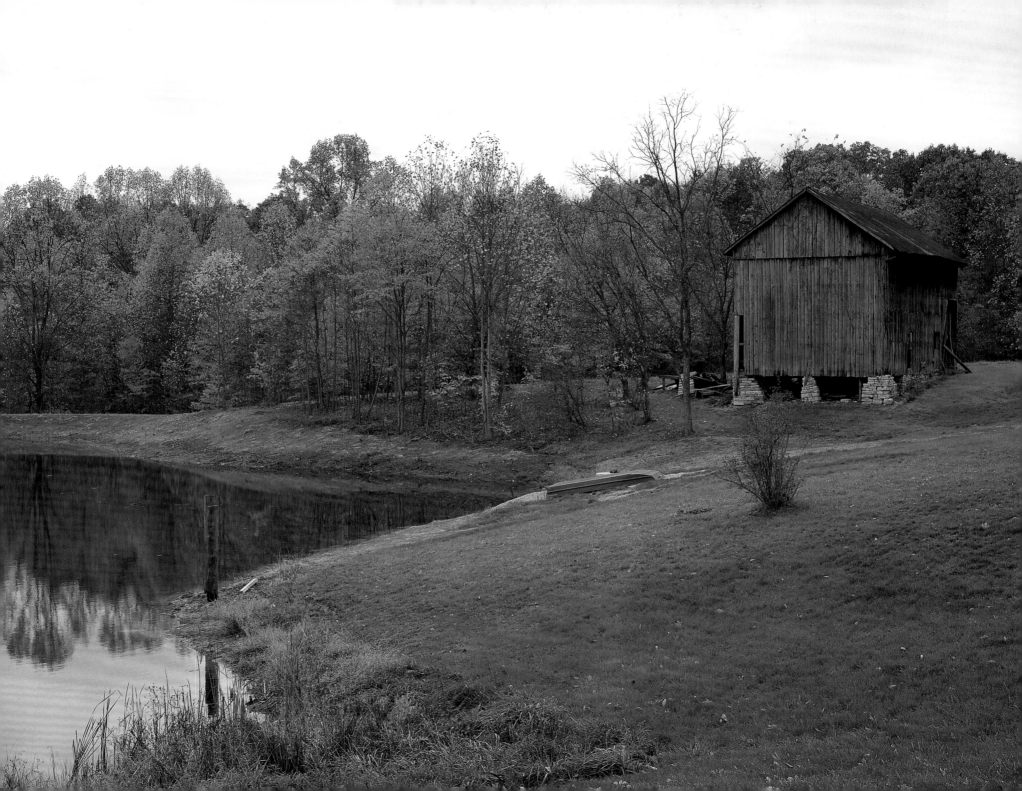

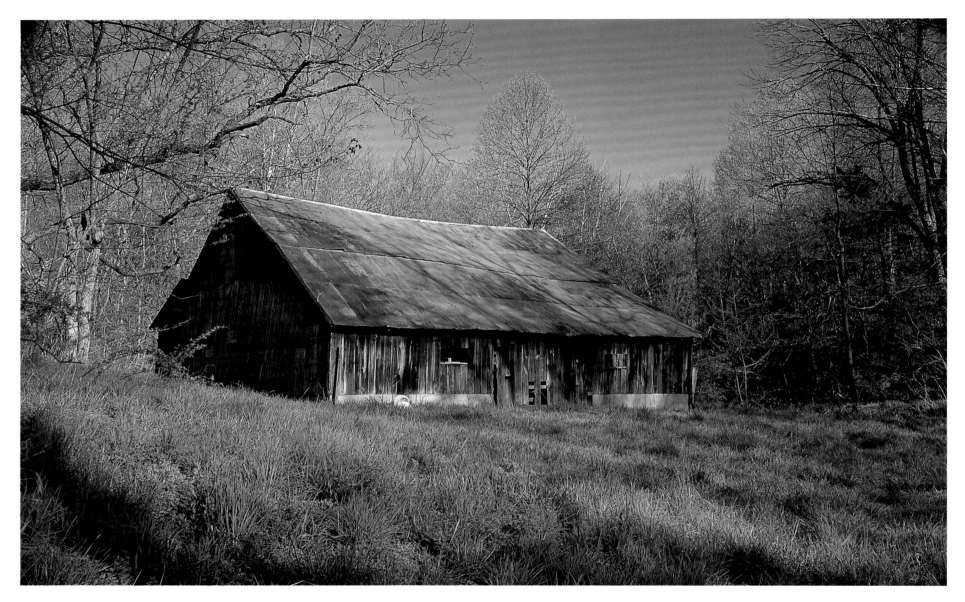

PARKE COUNTY

An early gable-roofed English barn

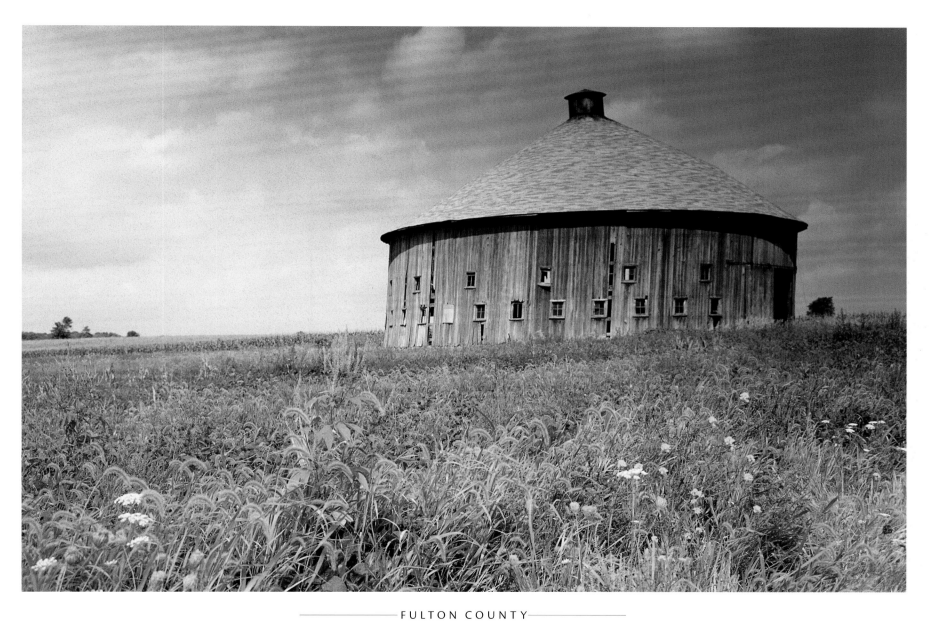

FULTON COUNTY

*A round hay and livestock barn with a conical
roof and a ventilator cupola*

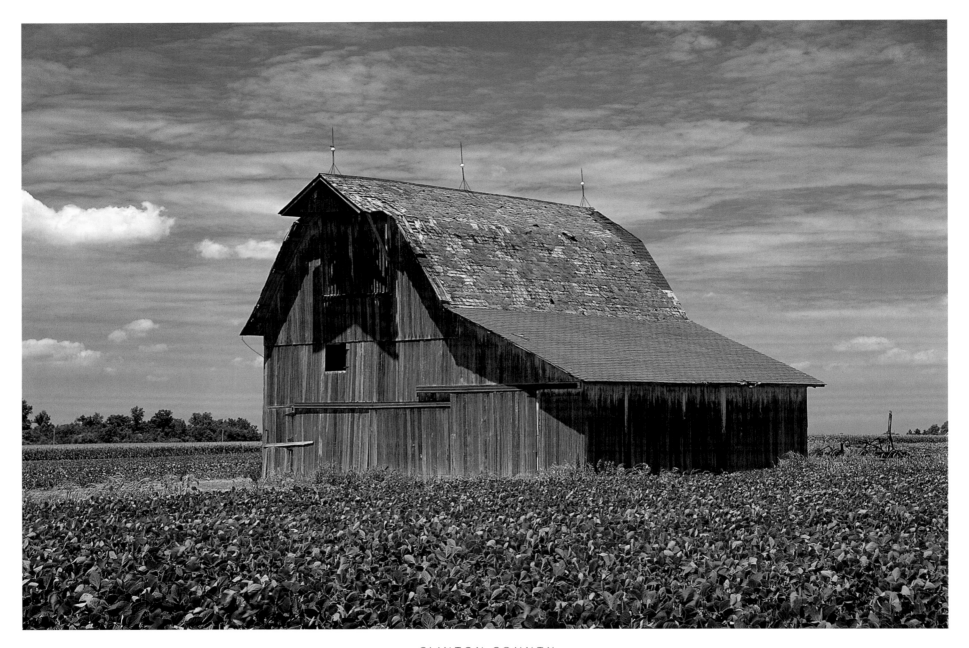

CLINTON COUNTY

*A transverse frame hay barn with a gambrel roof
and a shed addition features a hanging gable
and lightning arrestors*

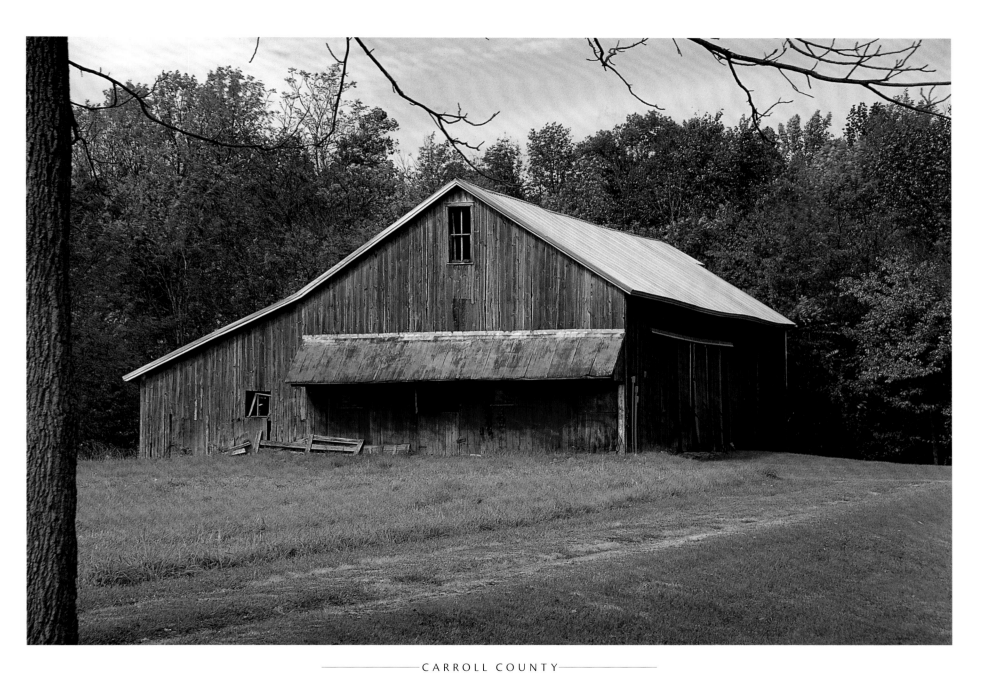

CARROLL COUNTY

*A gable-roofed English barn with a shed-roofed
addition and a pentice roof over
the gable end entry*

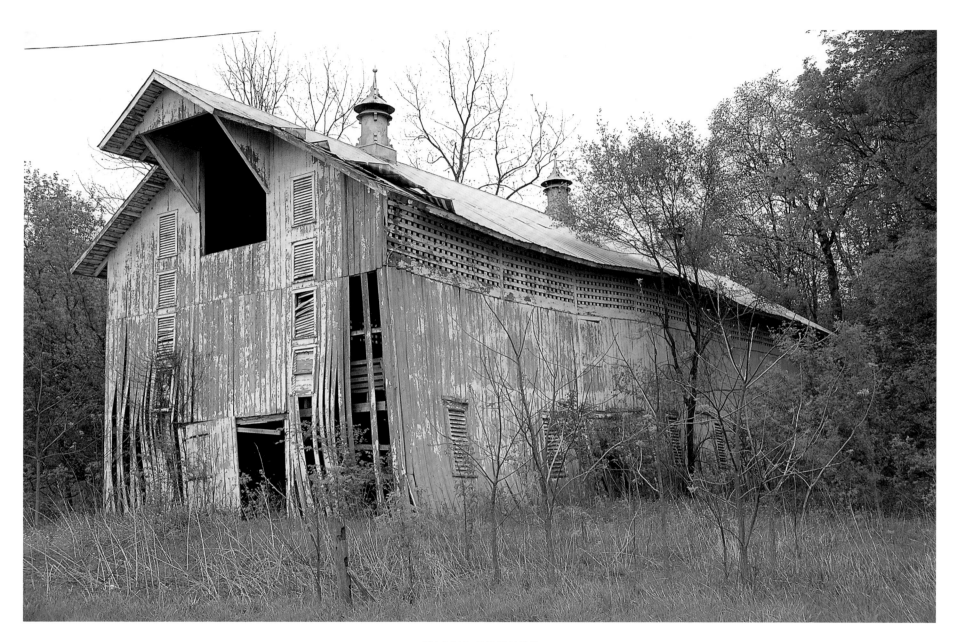

*A Victorian transverse frame hay barn with a gable roof
features louvered and latticed ventilation, decorative
metal ventilators, and a gabled hay hood*

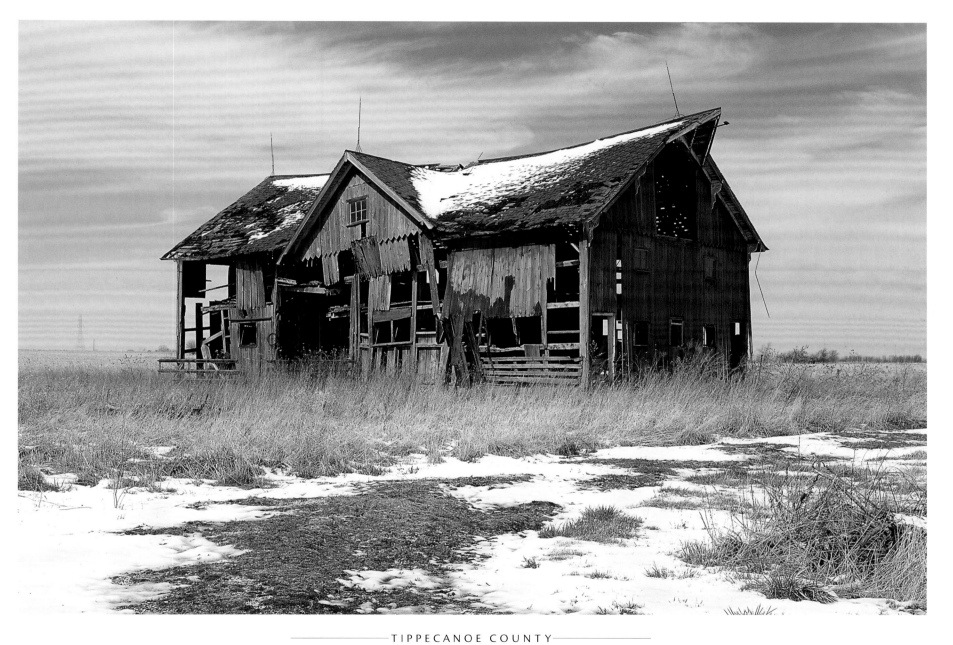

TIPPECANOE COUNTY

*A gable-roofed English barn featuring a decorative
side gable and a hay hood*

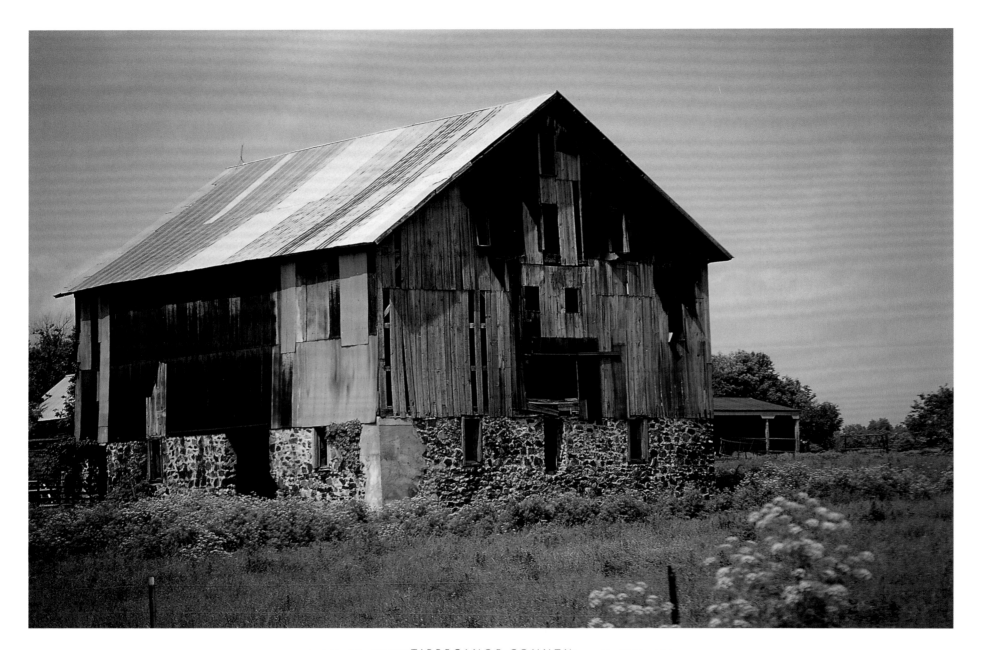

TIPPECANOE COUNTY

A cobblestone foundation barn with a gable roof

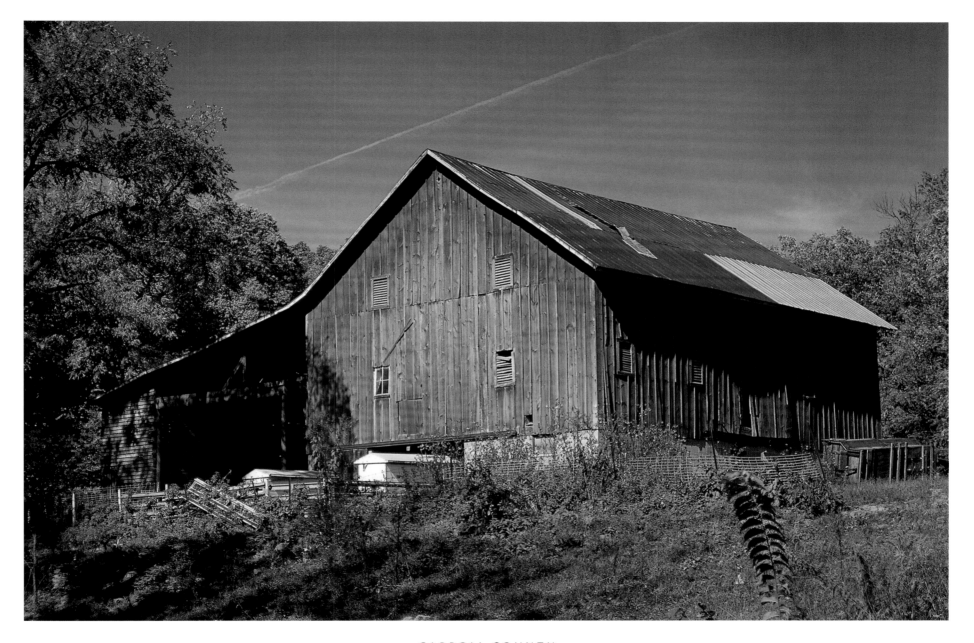

CARROLL COUNTY

A gable-roofed English foundation barn
with a shed-roofed addition

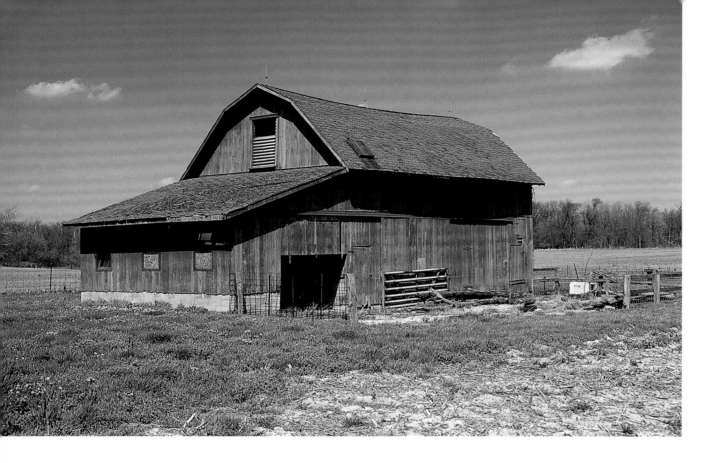
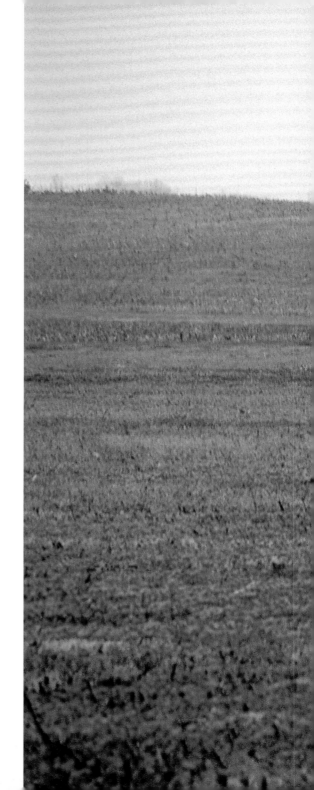

RUSH COUNTY

*A gambrel-roofed English barn with a
gable-end equipment shed*

(ABOVE)

JACKSON COUNTY

*A transverse frame barn with a gable roof and
a hipped equipment shed addition;
it features a hay hood*

(FACING)

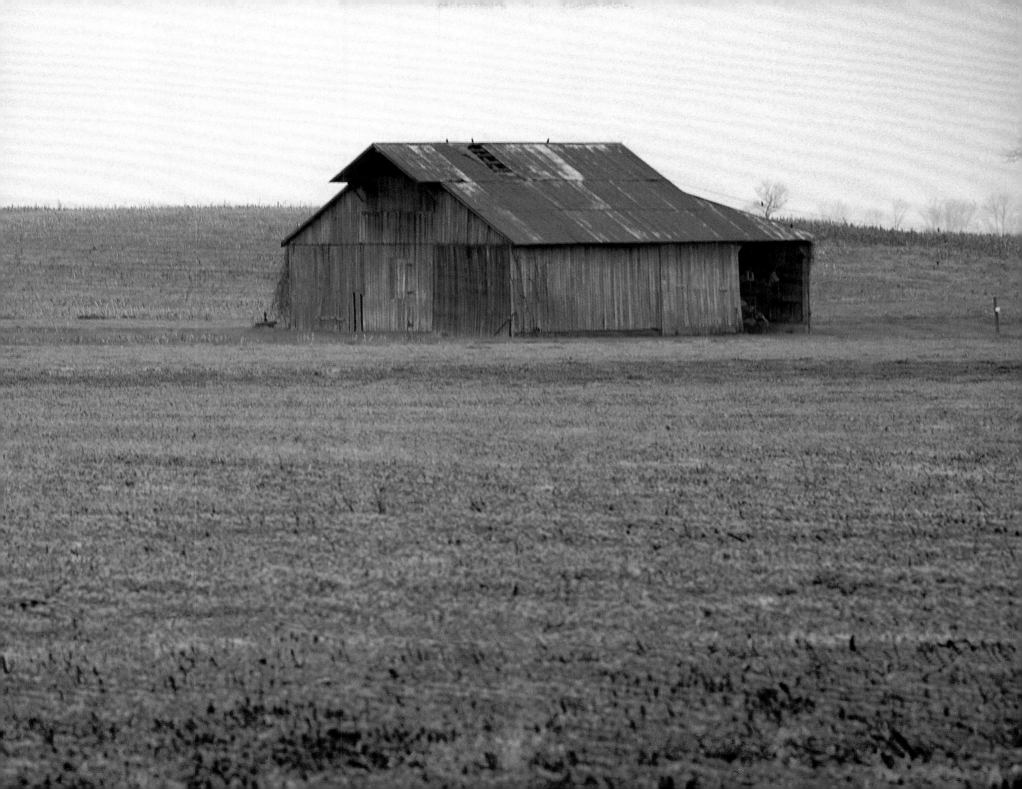

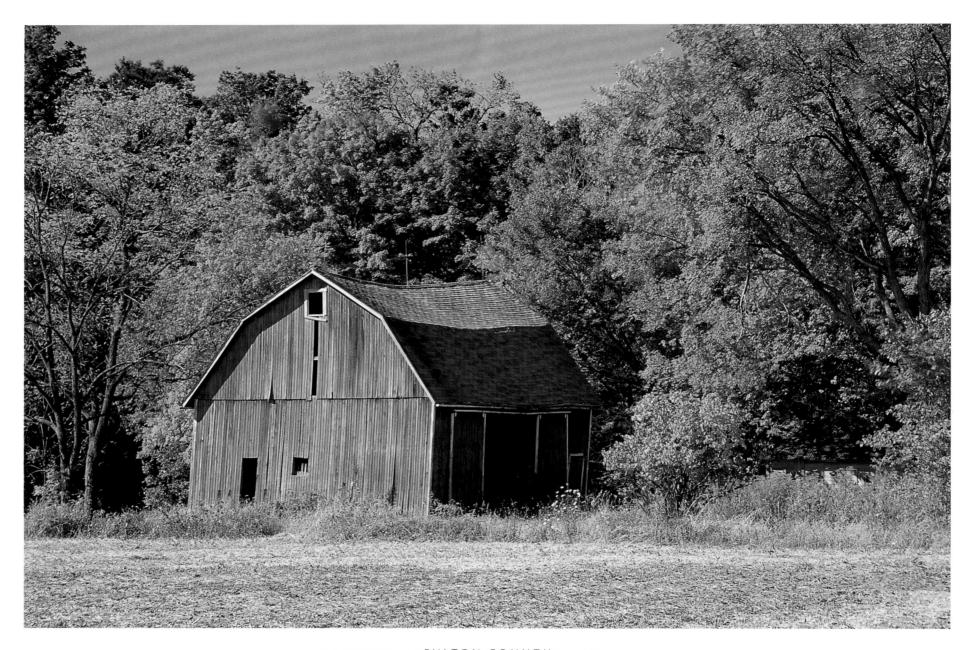

FULTON COUNTY

A gambrel-roofed English hay barn

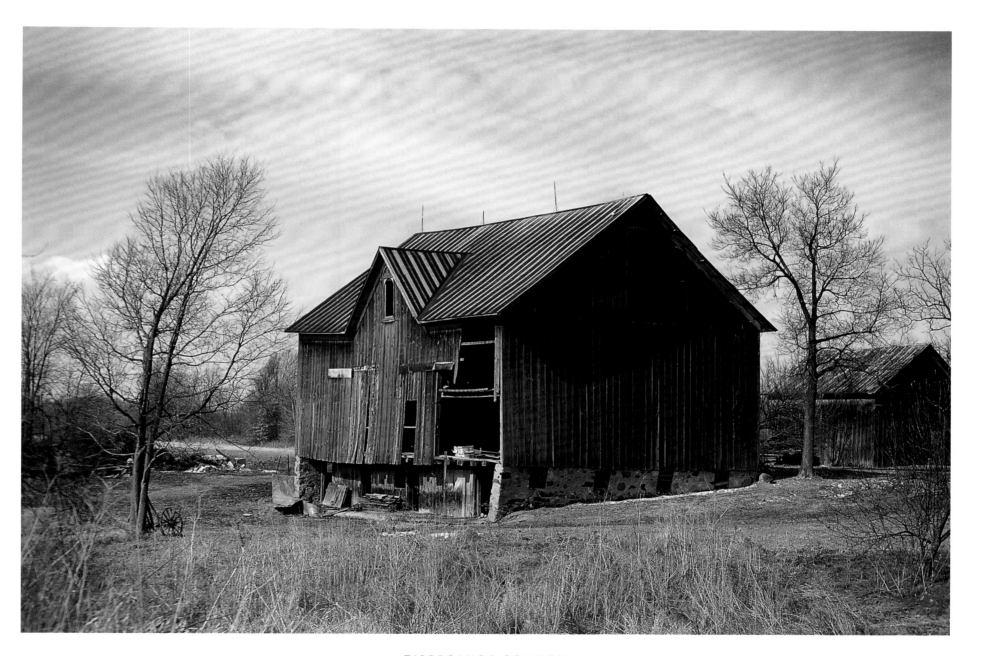

TIPPECANOE COUNTY

*A gable-roofed Pennsylvania bank barn with an unsupported
fore bay and a small, decorative side gable*

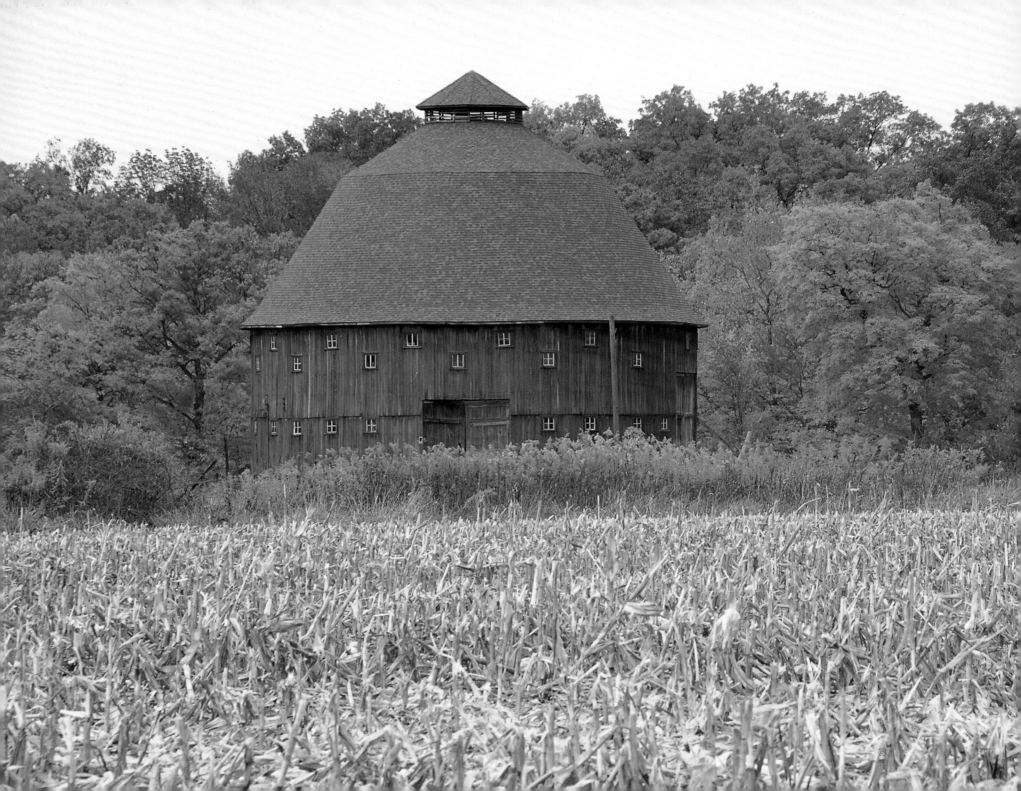

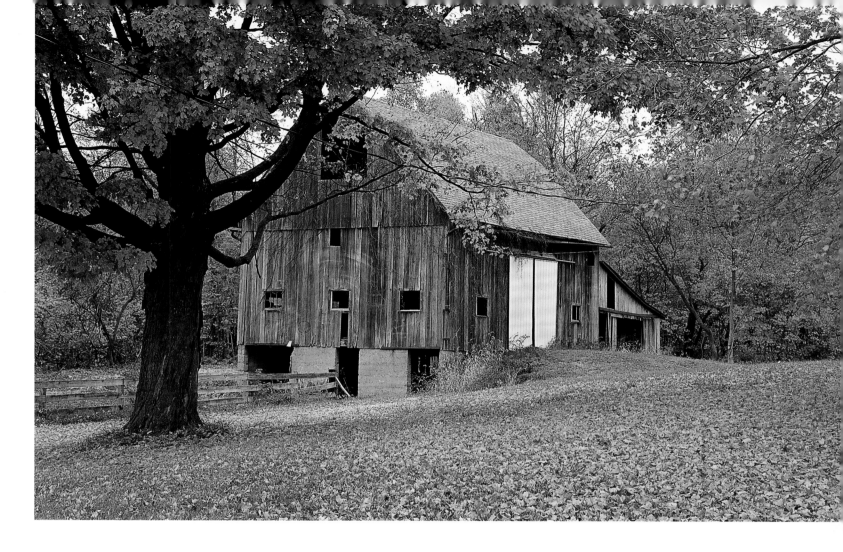

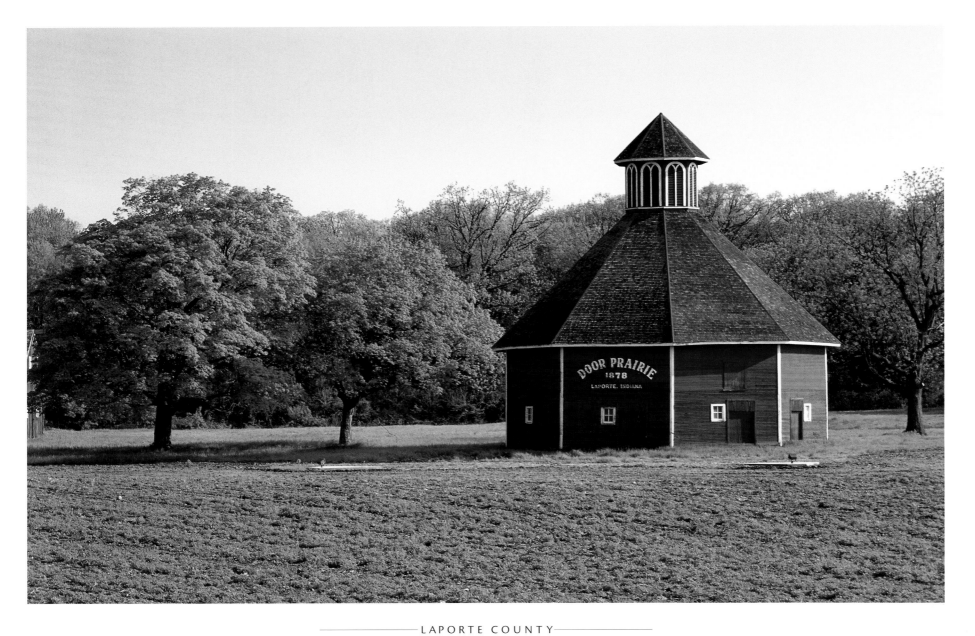

LAPORTE COUNTY

*A decorated, octagonal barn featuring a round ventilator
cupola with arched louvered openings*

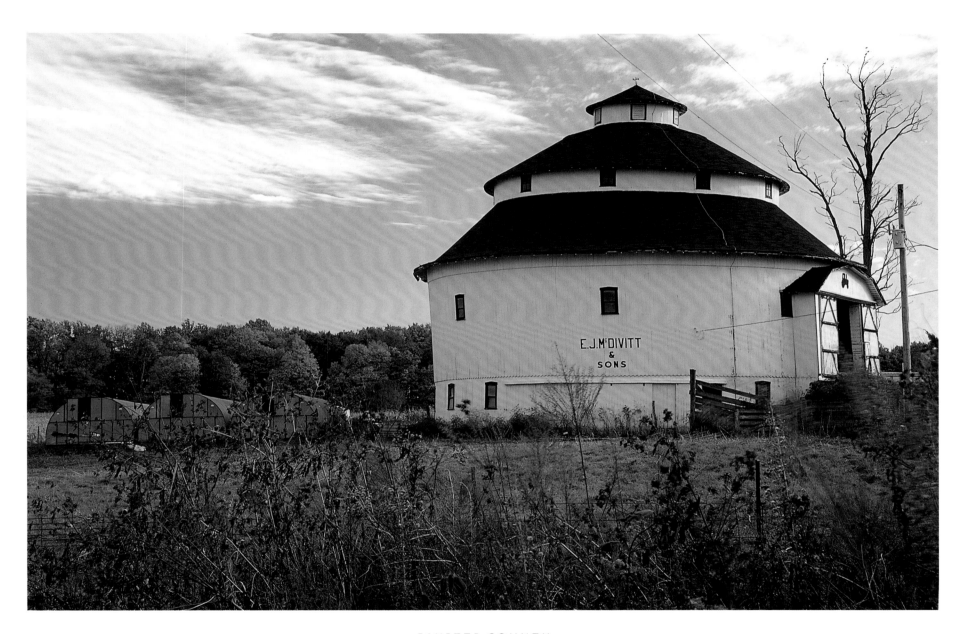

FAYETTE COUNTY

*A round barn with a clerestory level and a round ventilator
cupola features an entry porch with a barn bridge*

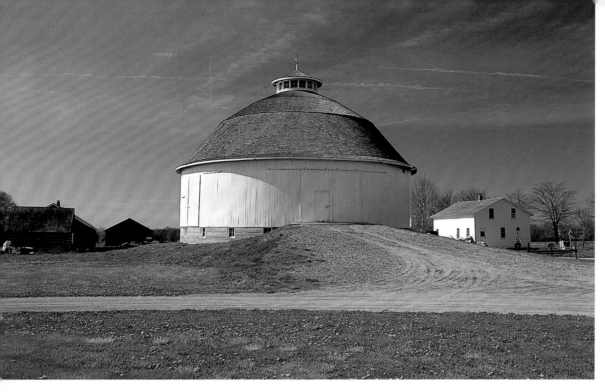

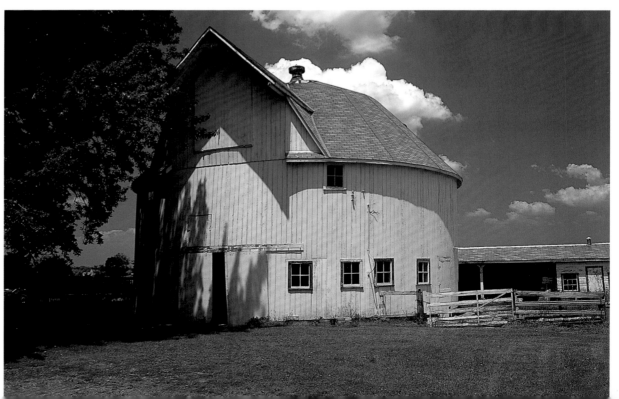

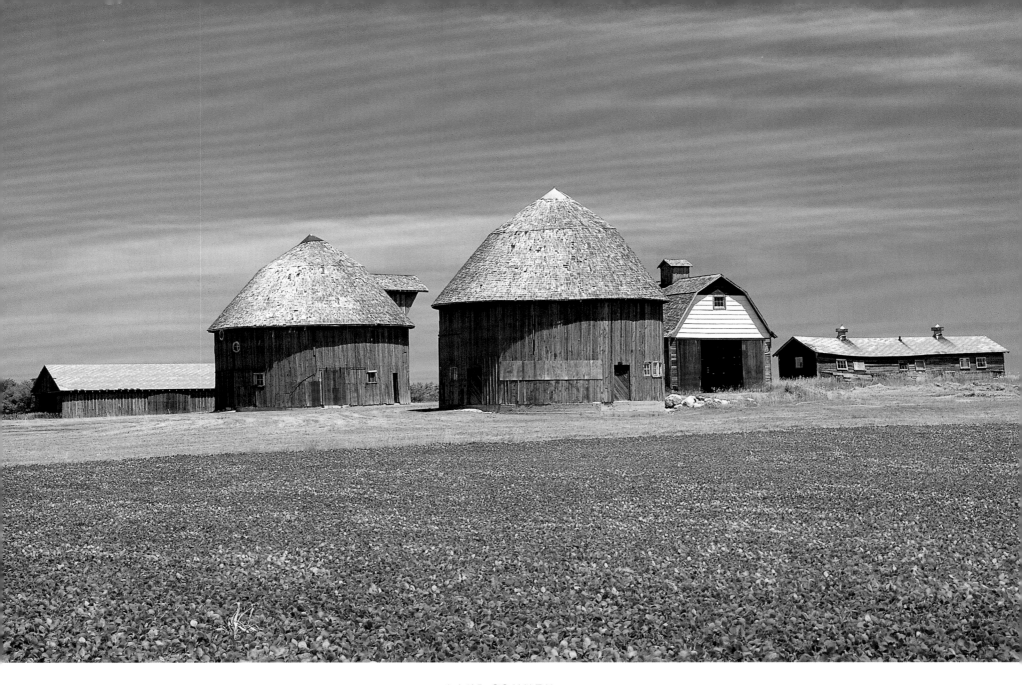

LAKE COUNTY

A farm complex featuring two round barns with conical roofs,
and a gambrel-roofed transverse frame barn

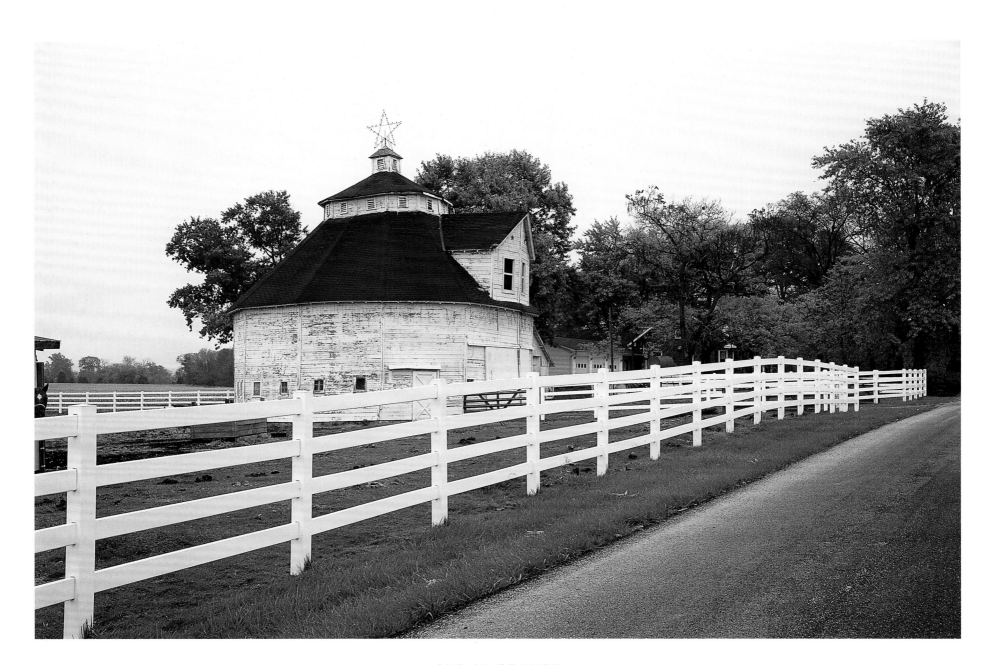

SHELBY COUNTY

*A round barn with a clerestory level and a ventilator cupola
features a gabled dormer over the entry*

A round bank barn with a raised masonry foundation features a two-pitch conical roof with decorative shingles

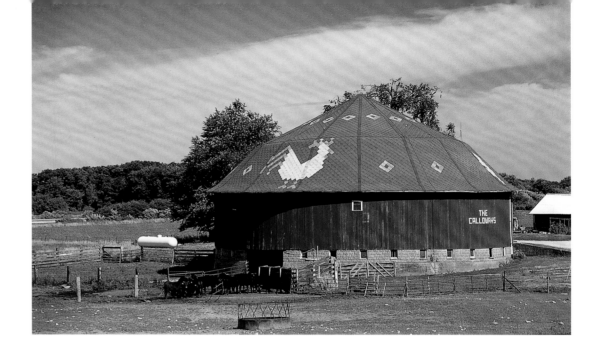

A gambrel-roofed, decorated English barn features metal ventilators, shed roof dormers, pedimented windows, Dutch doors, and clapboard siding

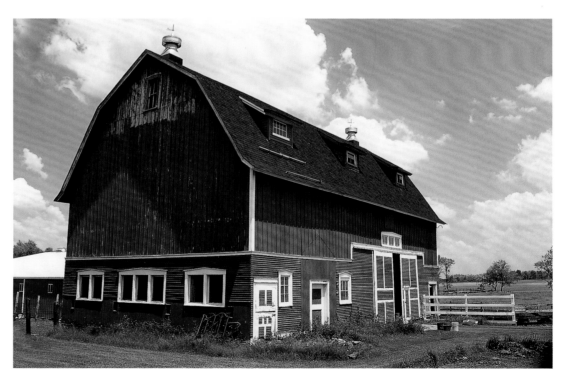

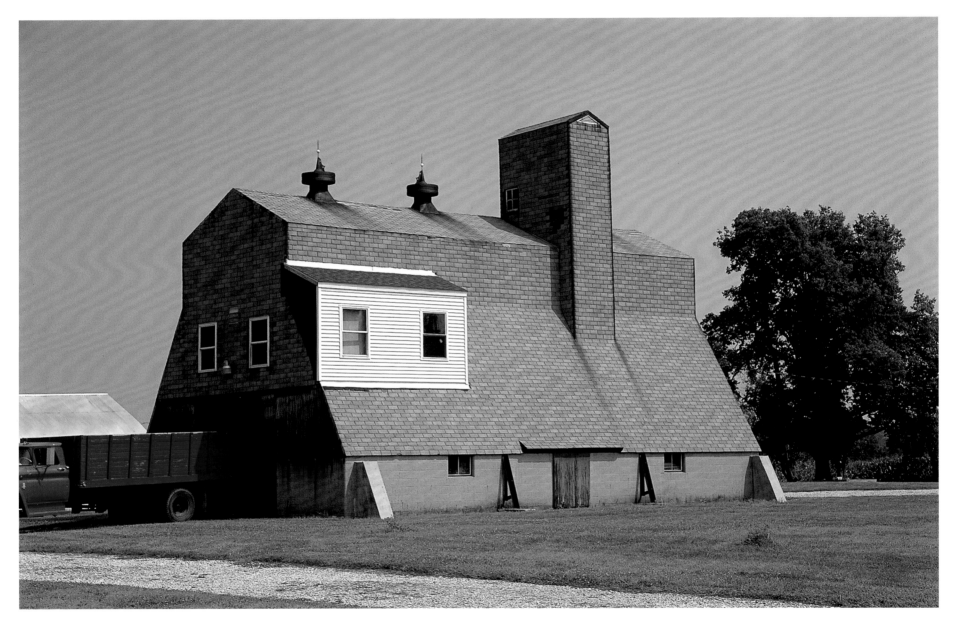

HANCOCK COUNTY

A transverse frame foundation barn with a monitor roof
features metal ventilators and a granary

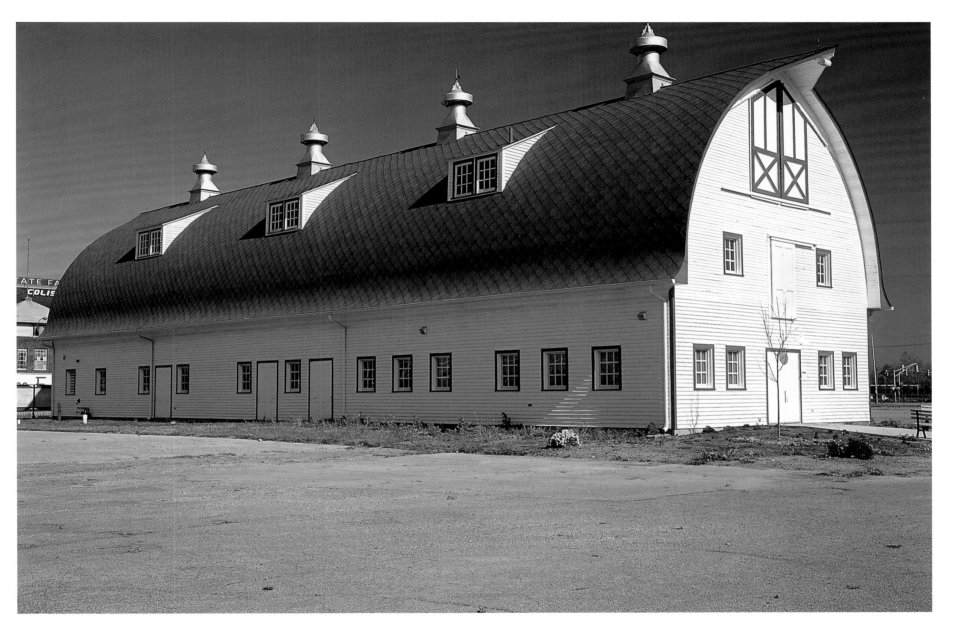

*A Wisconsin dairy barn with a round helmet roof
features metal ventilators, shed roof
dormers, and a hay hood*

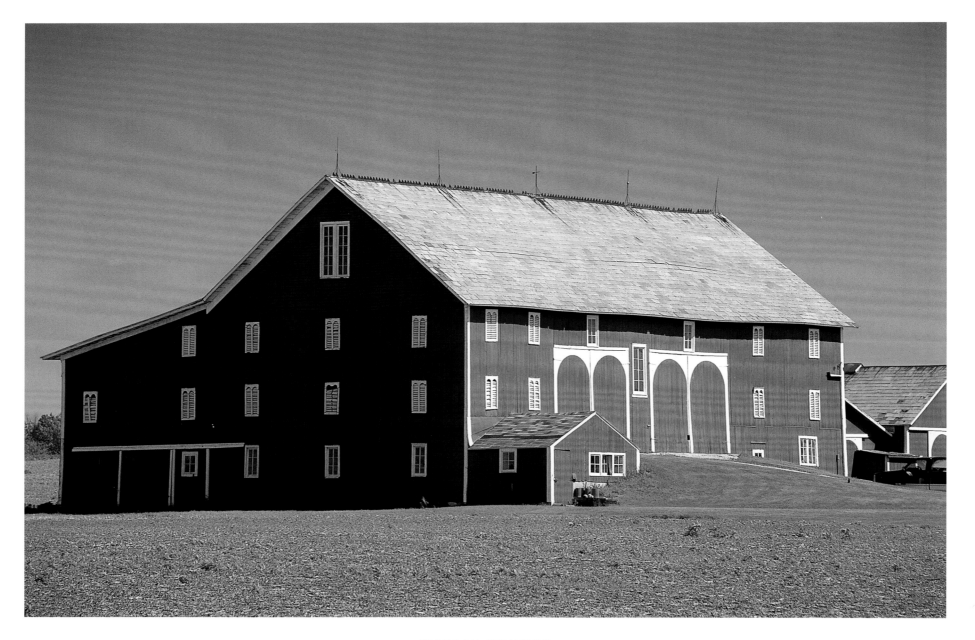

WABASH COUNTY

*A gable-roofed, decorated English bank barn with a large
shed-roofed addition features painted arched doors,
painted windows, and a slate roof*

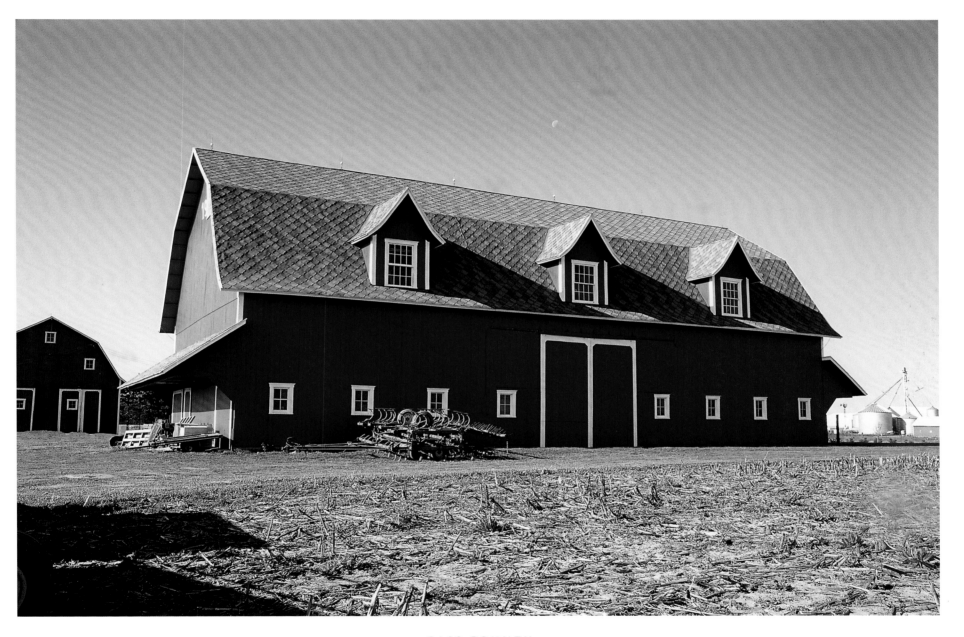

*A gambrel-roofed English dairy barn with a pentice hood
on each gable end also features decorative
gabled ventilator dormers*

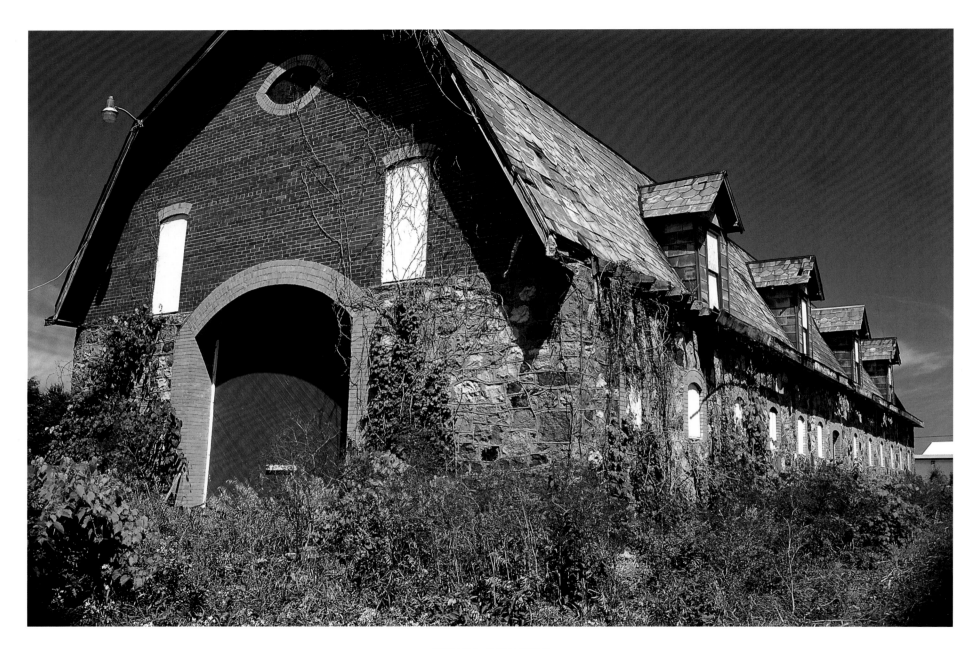

WHITE COUNTY

*A gambrel-roofed transverse masonry dairy barn features a
decorative slate roof, gabled ventilator dormers, an oculus window,
and a segmentally arched entrance and windows*

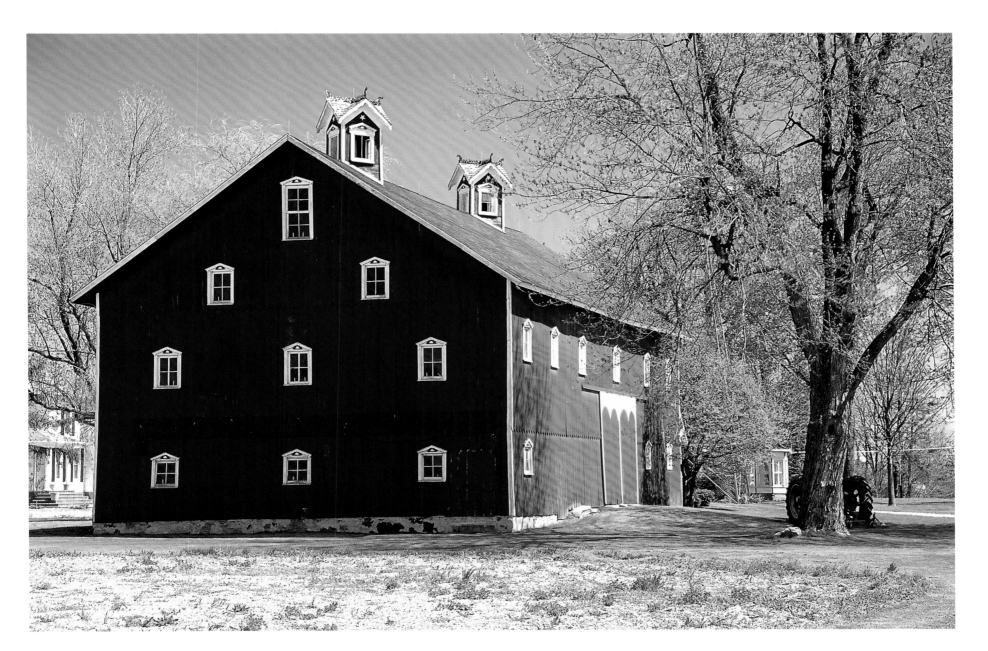

ALLEN COUNTY

A gable-roofed, decorated English barn features pedimented
windows, painted double-arched doors, and cross-gable
cupola ventilators with Victorian metalwork

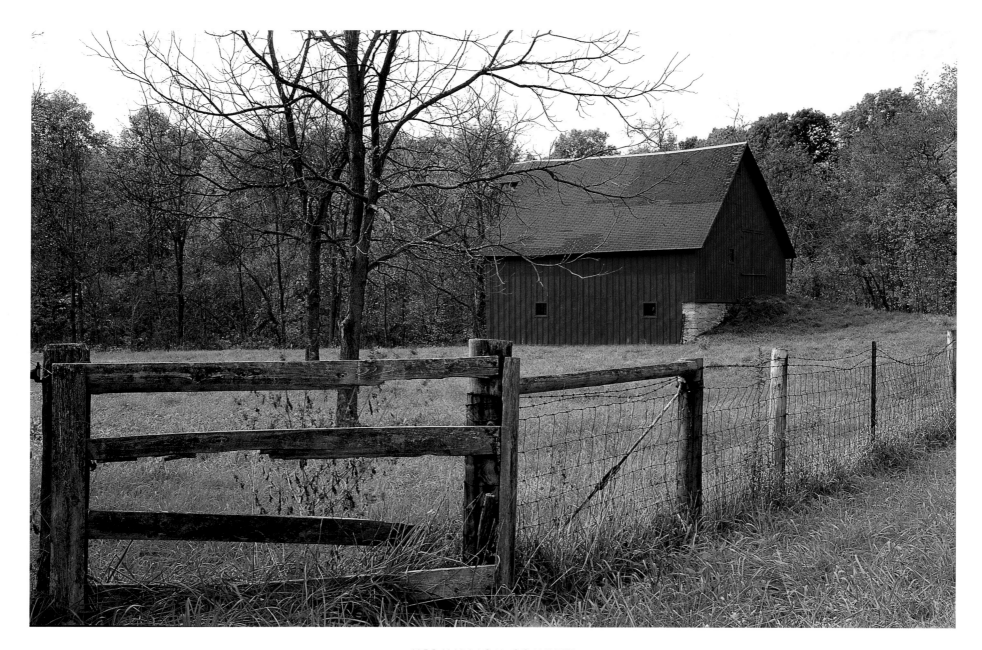

VERMILLION COUNTY

A Dutch bank barn with a gable roof

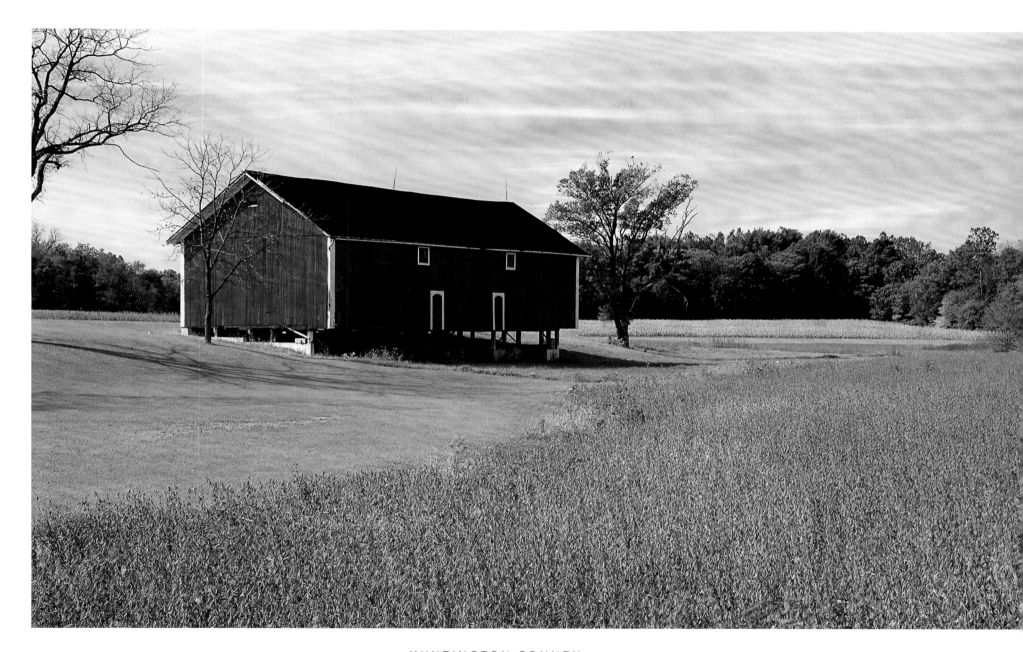

A decorated English bank barn with a gable roof

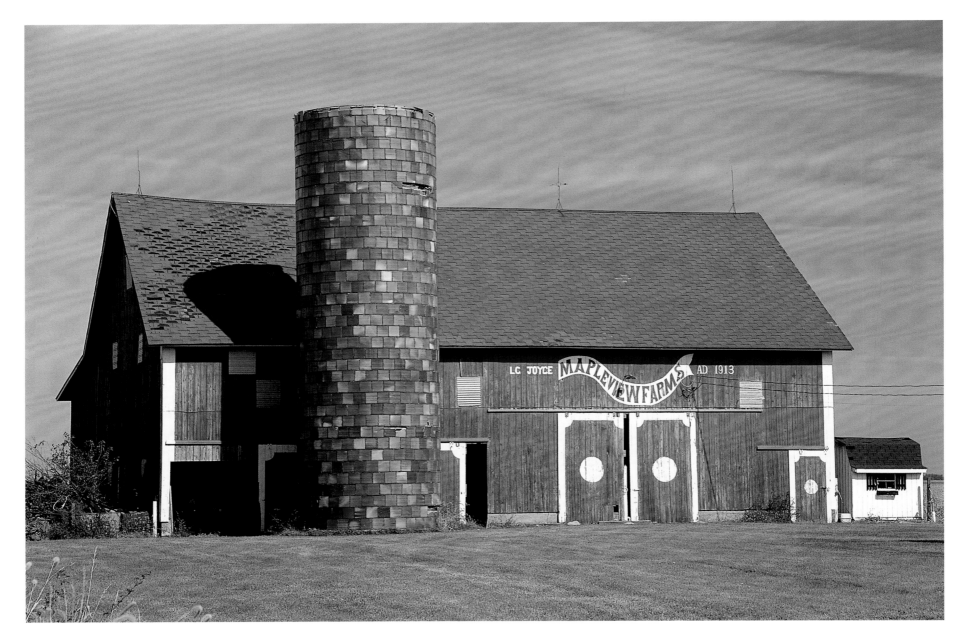

CARROLL COUNTY

*A gable-roofed, decorated English barn with a shed-roofed
addition features painted doors, windows, and corner
posts, as well as a glazed terracotta–tile silo*

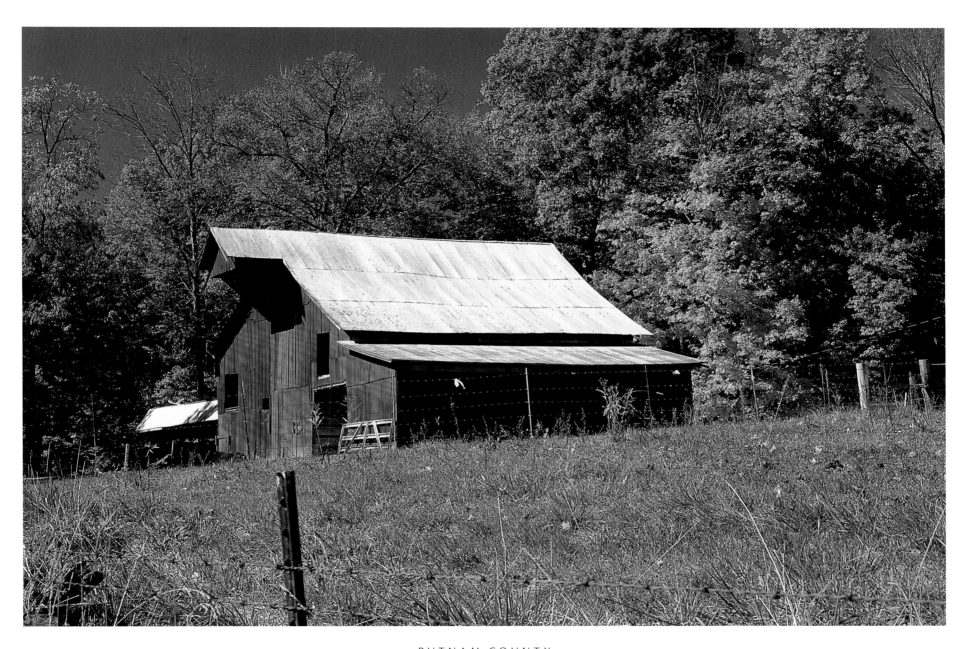

PUTNAM COUNTY

*A gable-roofed transverse frame barn with a
shed addition and hay hood*

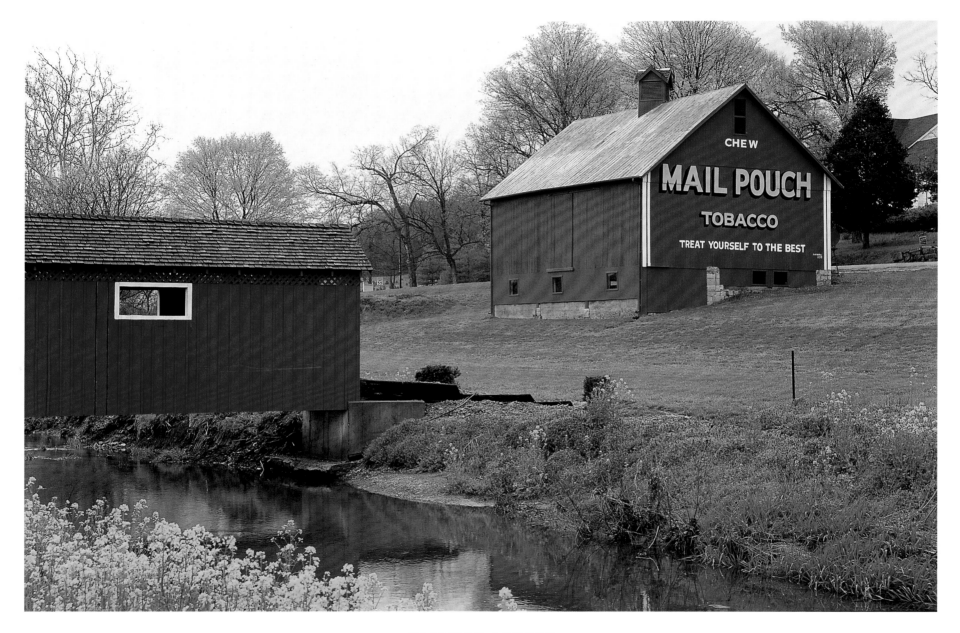

—————————— HARRISON COUNTY ——————————

A gable-roofed English bank barn with a stone foundation
and a cross-gable ventilator cupola

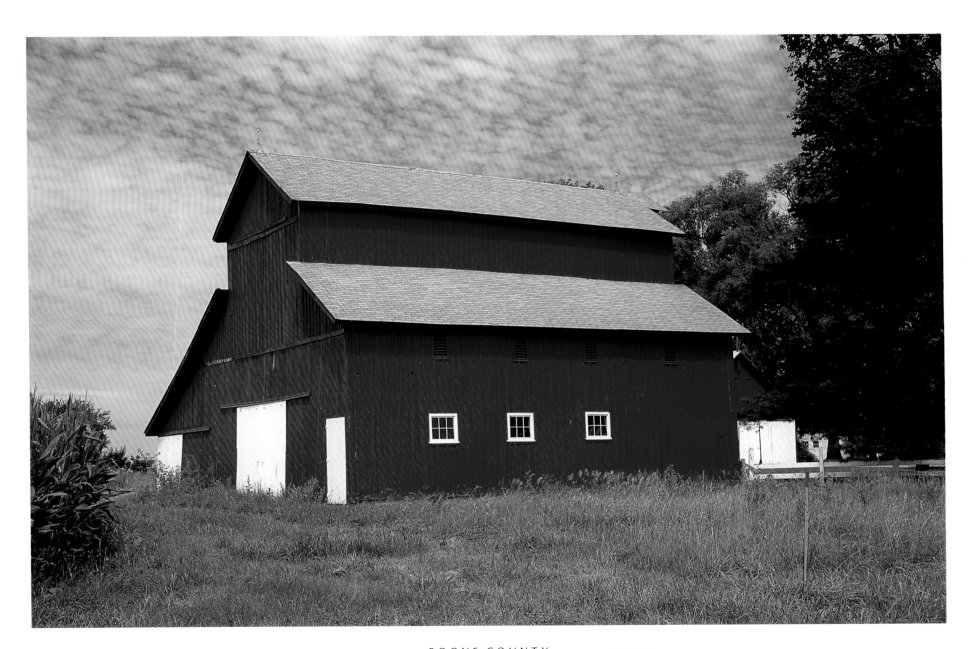

BOONE COUNTY

*A transverse frame barn with an
asymmetrical monitor roof*

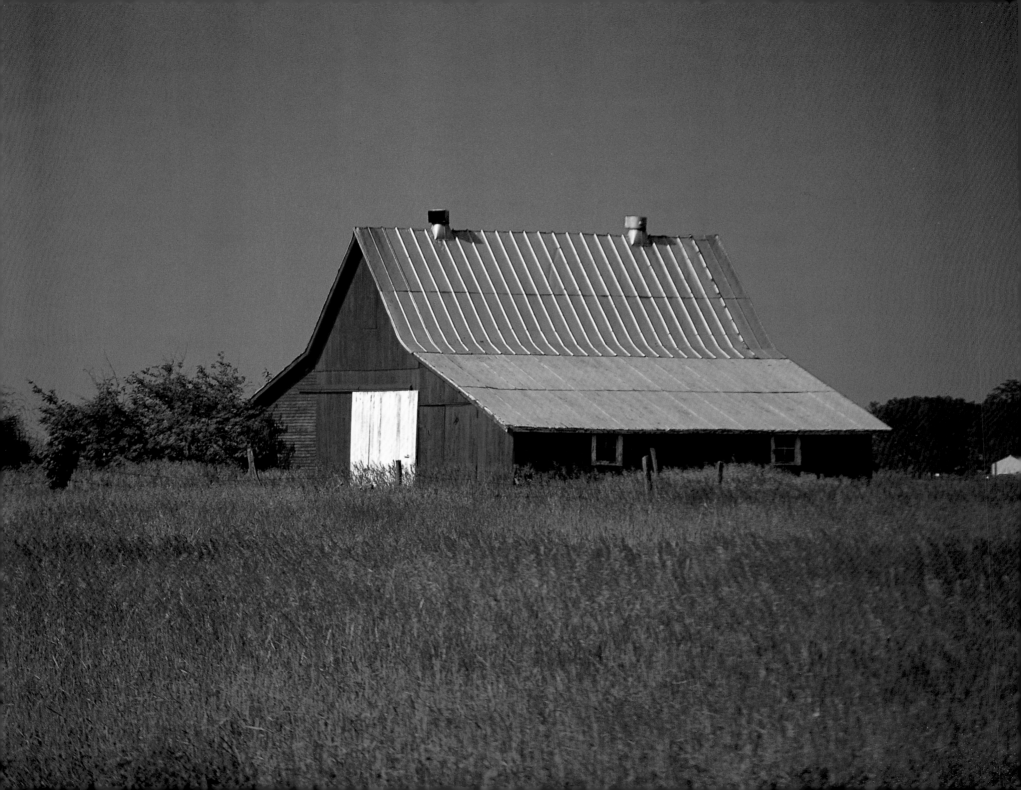

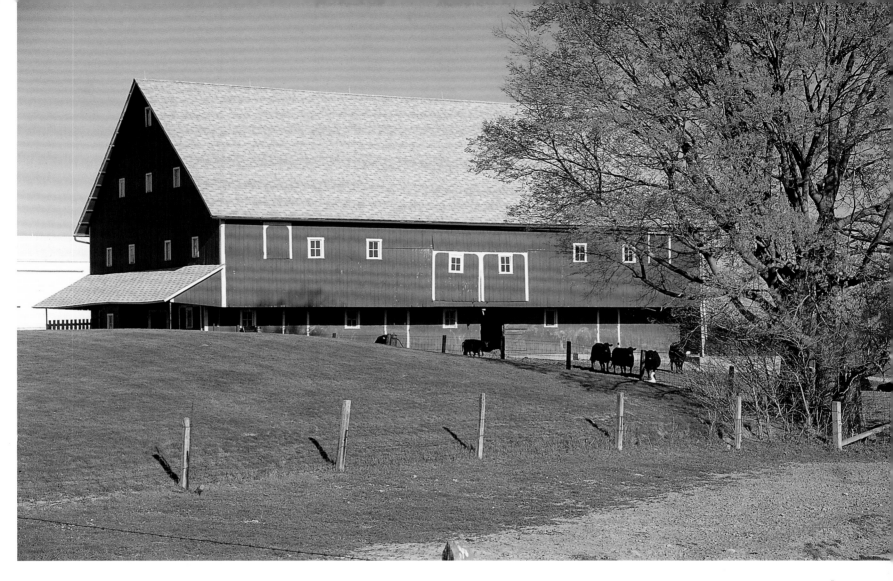

————CASS COUNTY————

A gable-roofed Pennsylvania barn with an unsupported
fore bay and a gable-end pentice hood

(ABOVE)

————BOONE COUNTY————

A broken-gable transverse frame barn
with metal ventilators

(FACING)

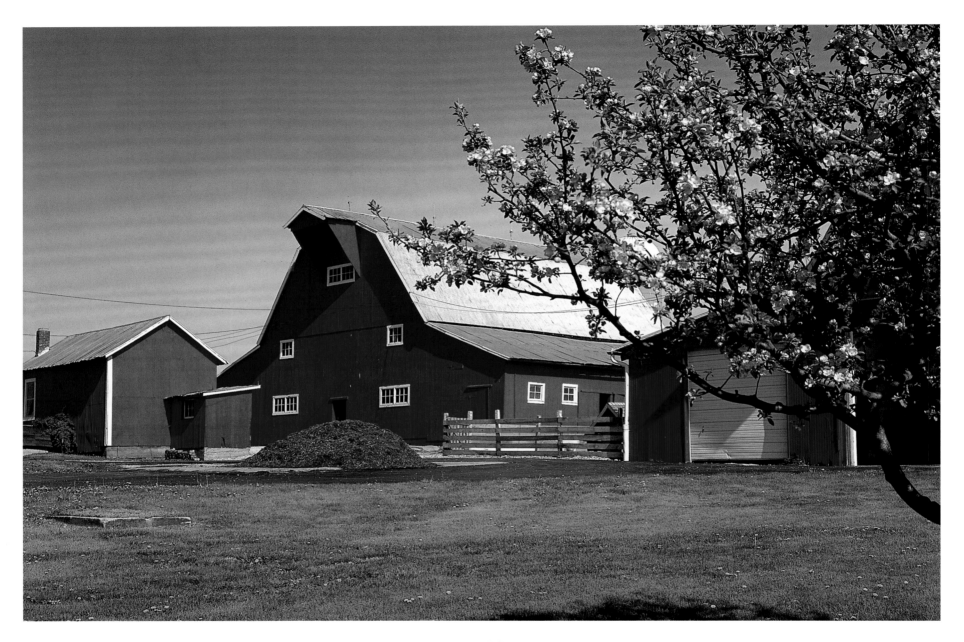

PUTNAM COUNTY

*A farm complex featuring a gambrel-roofed hay and livestock
barn with large side sheds and a hay hood*

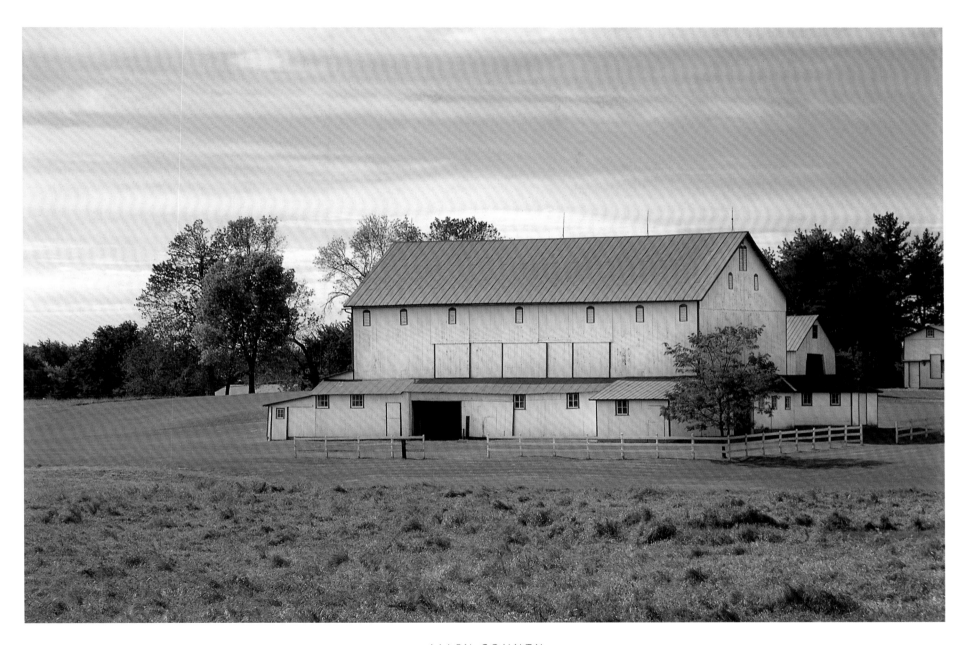

ALLEN COUNTY

A gable-roofed English barn variation with
surrounding shed-roofed additions

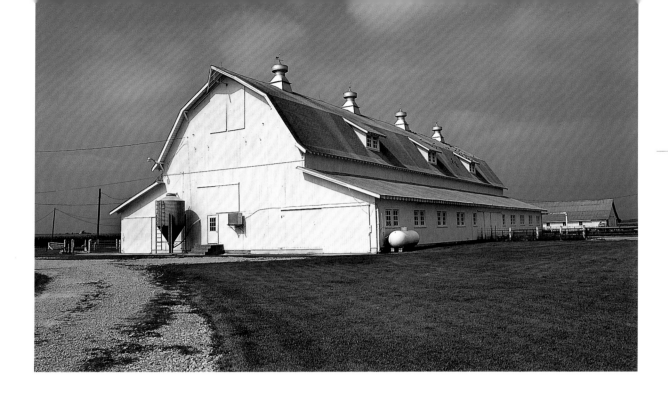

HAMILTON COUNTY

A gambrel-roofed hay and livestock barn with large shed-roofed side aisles features metal ventilators, ventilator dormers, and a hay hood

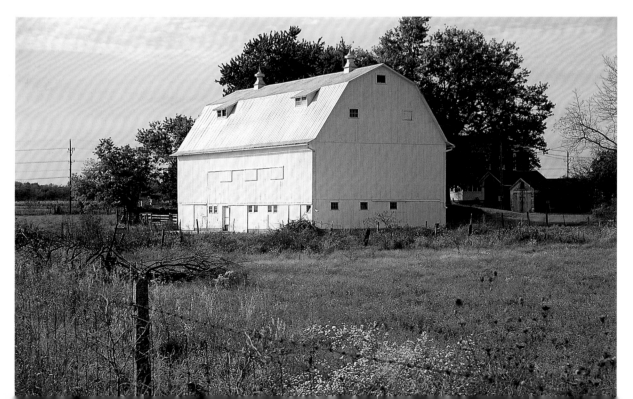

WABASH COUNTY

A gambrel-roofed hay and livestock barn with metal ventilator cupolas and ventilator dormers

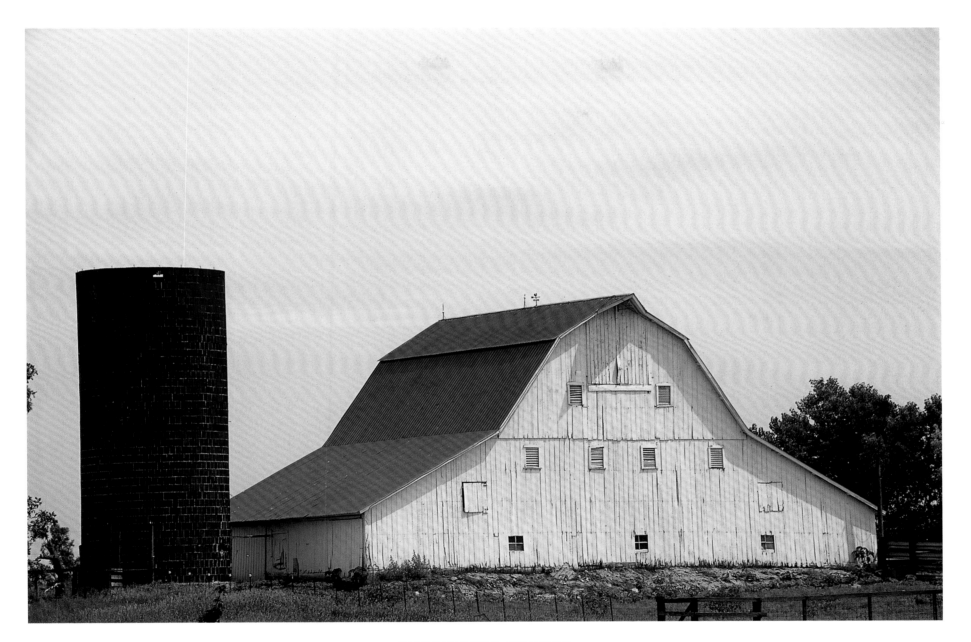

*A gambrel-roofed barn with large shed-roofed
additions features a ceramic-tile silo*

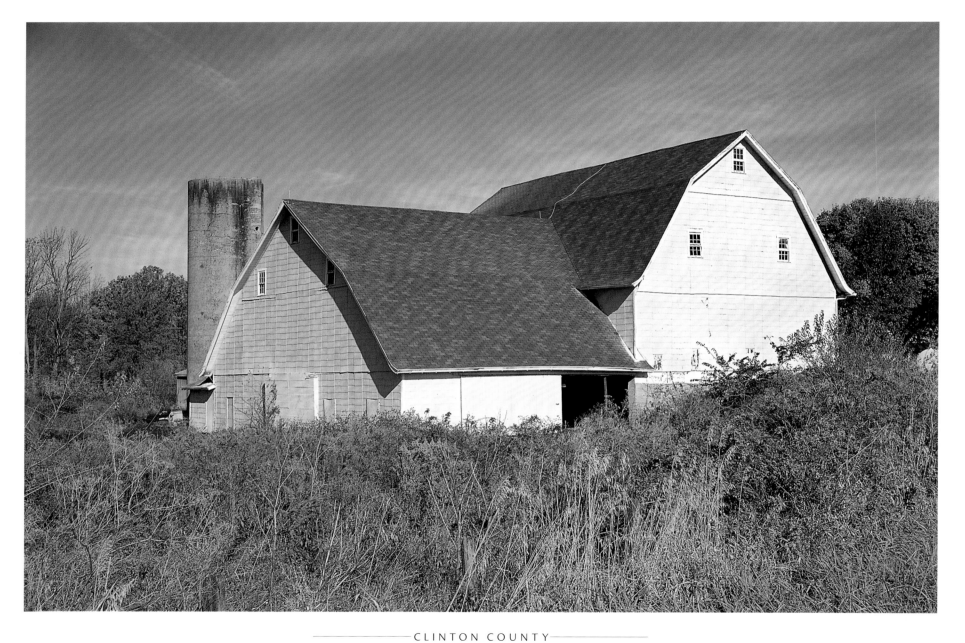

CLINTON COUNTY

A gambrel-roofed three-end barn with a concrete silo

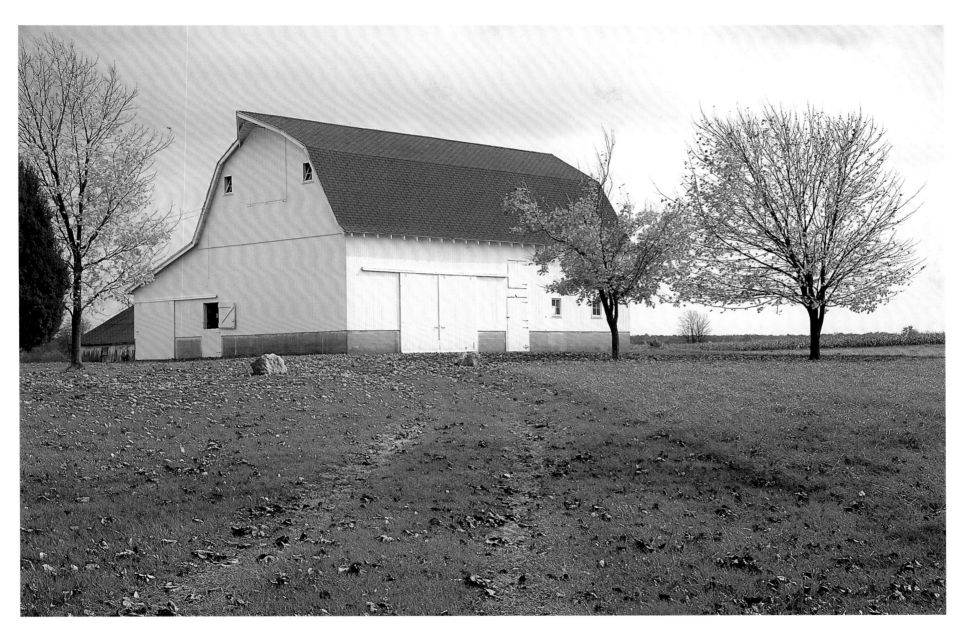

*A gambrel-roofed English barn with a concrete foundation
and shed-roofed side aisle features a hay hood*

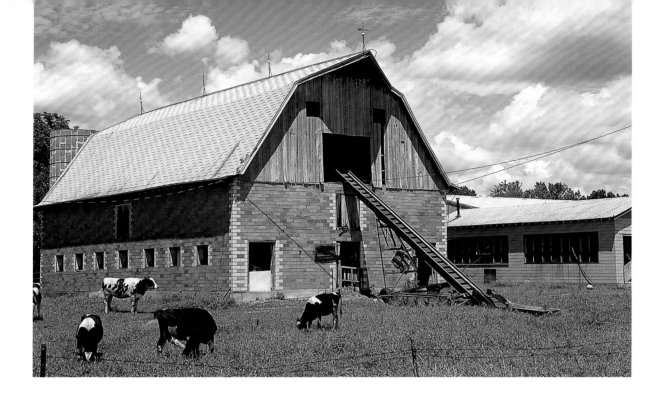

VIGO COUNTY

A dairy farm complex featuring a gambrel-roofed, ceramic tile foundation barn

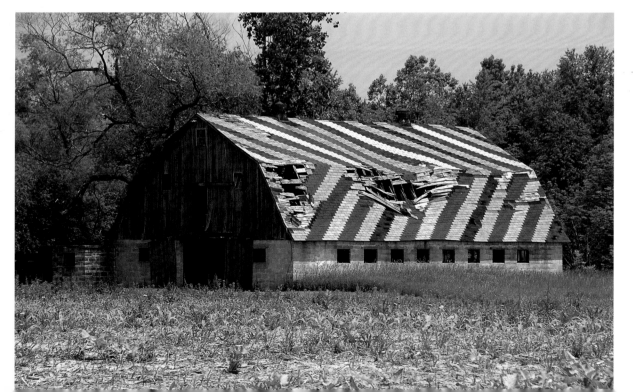

KOSCIUSKO COUNTY

A gambrel-roofed transverse frame foundation barn features metal ventilators and decorative roof shingles

(LEFT)

FOUNTAIN COUNTY

A small, extended gable-roofed barn or outbuilding with a cupola

(FACING)

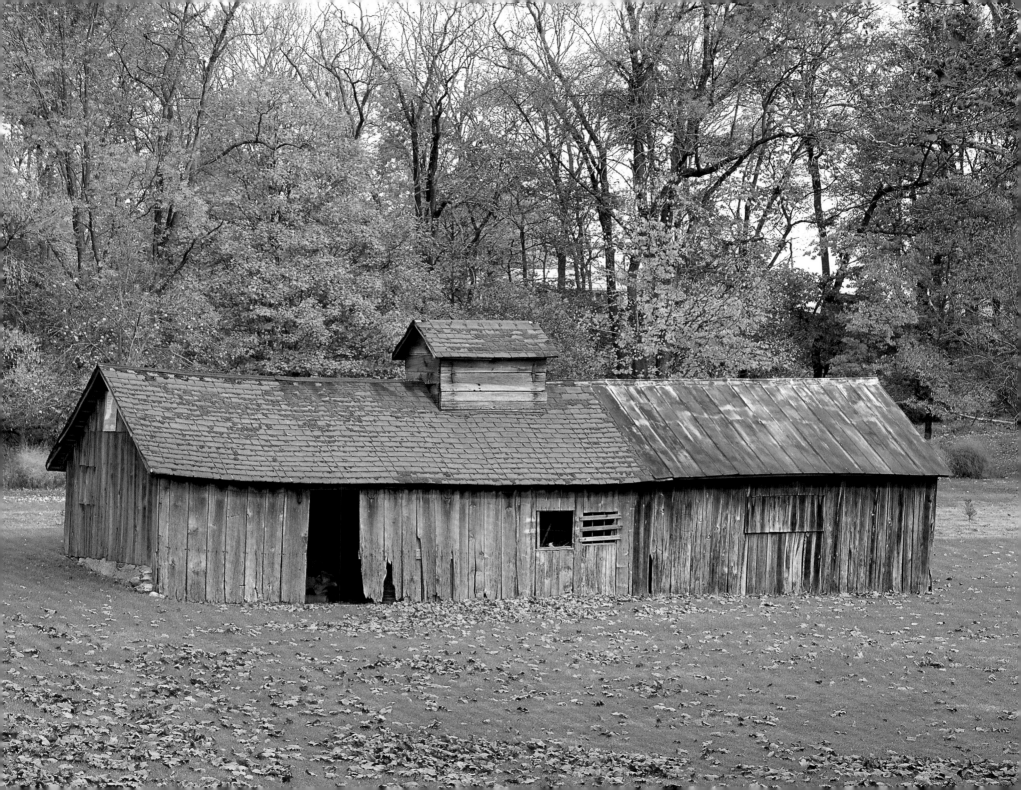

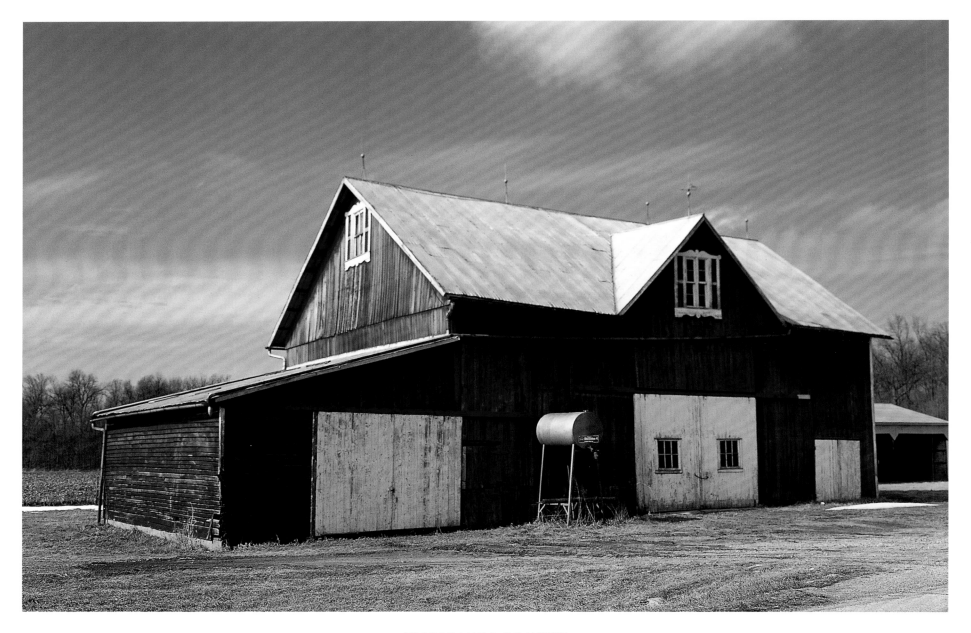

TIPPECANOE COUNTY

*A gable-roofed English barn with a side gable and
a shed-roofed equipment addition features
decorative painted windows and doors*

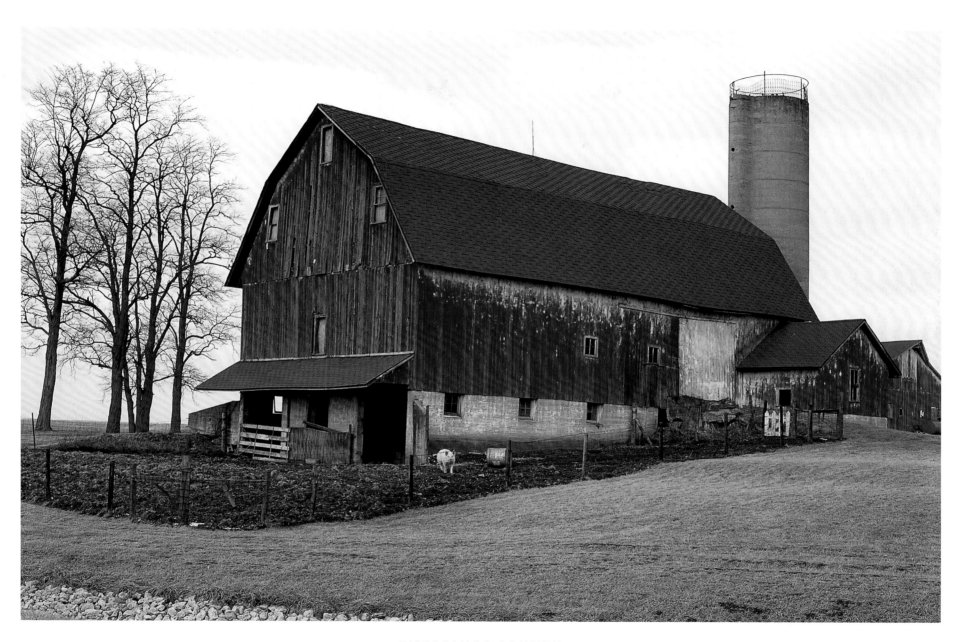

A gambrel-roofed English bank barn with a gable-end
pentice roof features a small gable-roofed
addition and a concrete silo

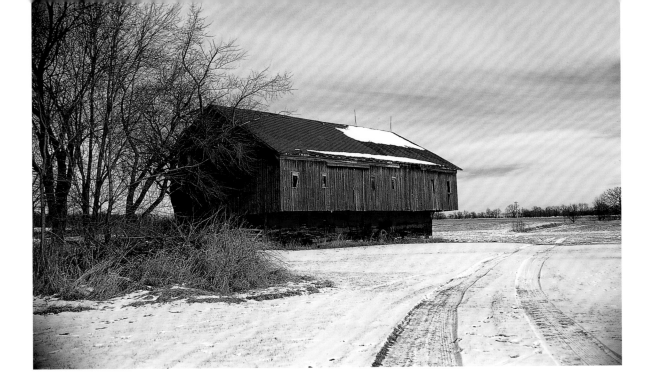

A gable-roofed Pennsylvania barn with an unsupported fore bay

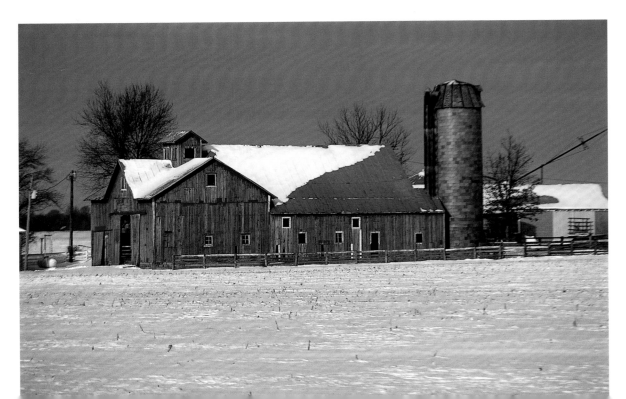

A gable-roofed English barn with Gothic side-gable and cupola also features a large gable-roofed addition on the rear and a terracotta silo

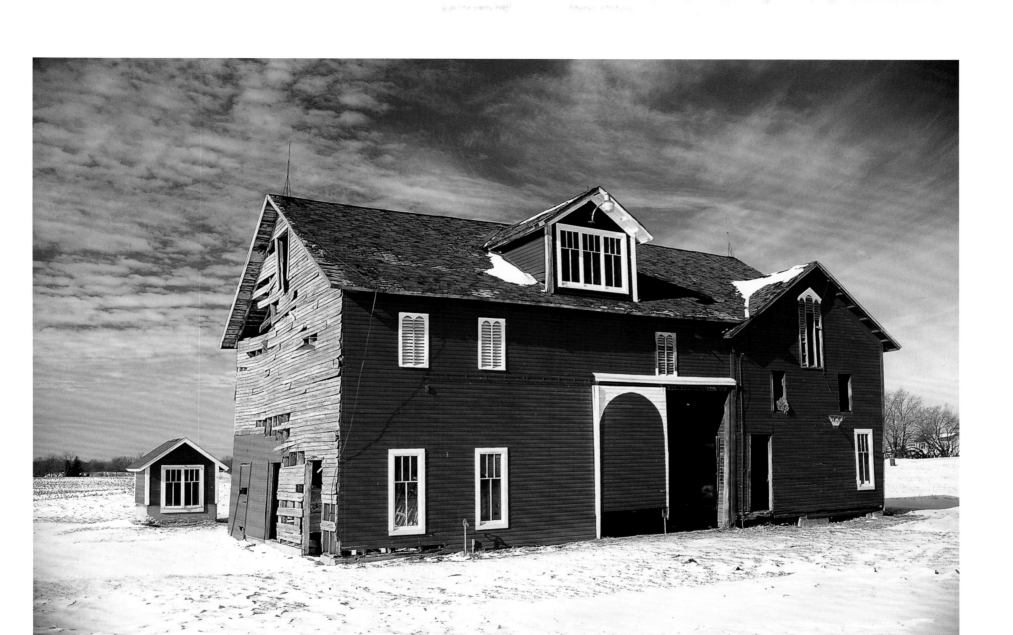

WHITLEY COUNTY

*A gable-roofed, decorated English barn with a shallow gabled
entry porch features decorative painted windows
and arched doors, and a gabled dormer*

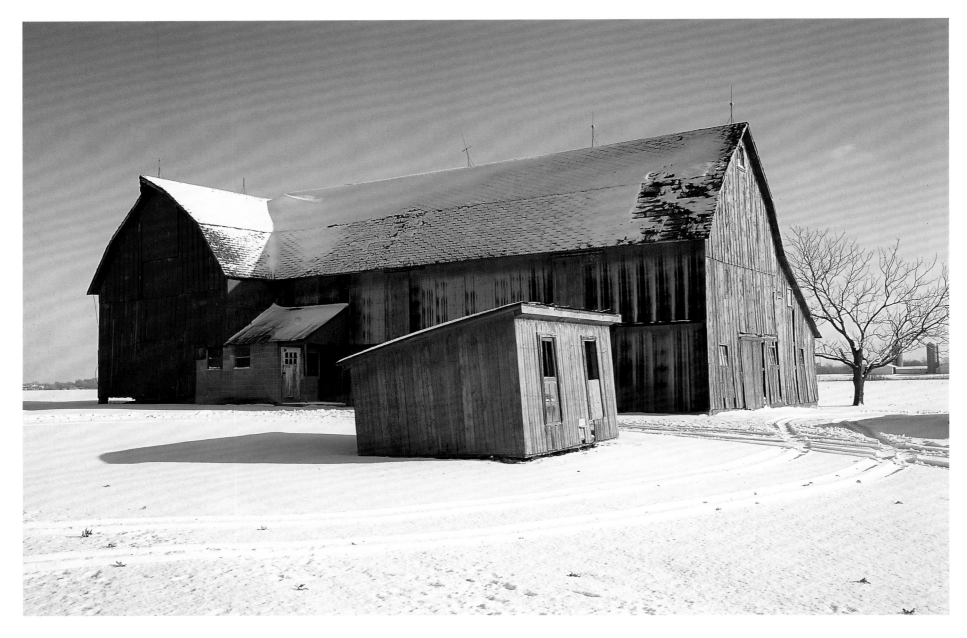

LAKE COUNTY

A cross-gambrel transverse frame barn
with shed additions

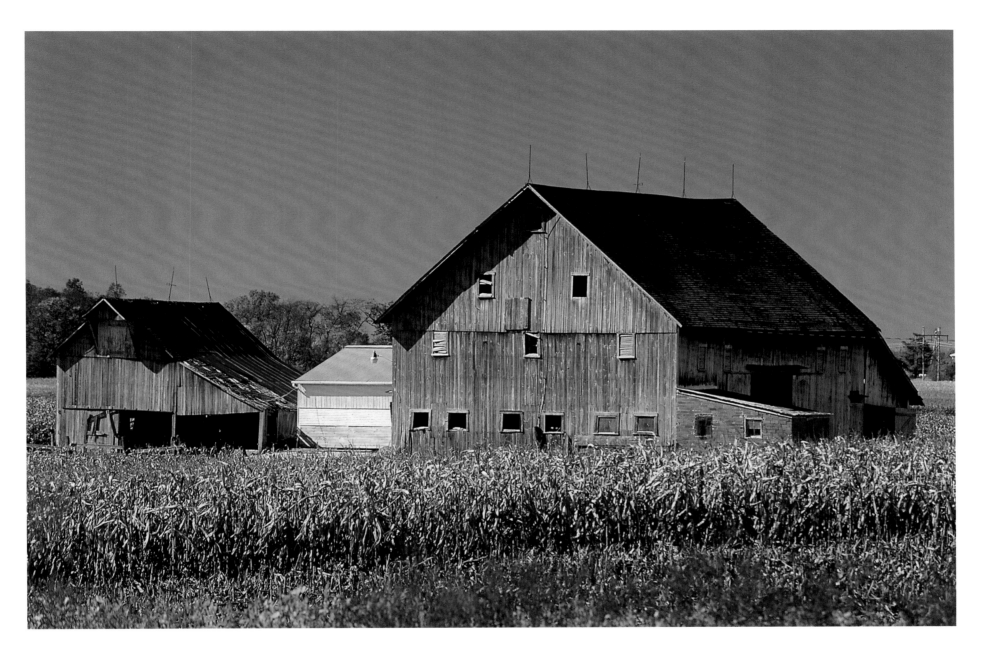

MARION COUNTY

*A farm complex featuring a gable-roofed English barn
with an equipment shed and a small
shed-roofed masonry addition*

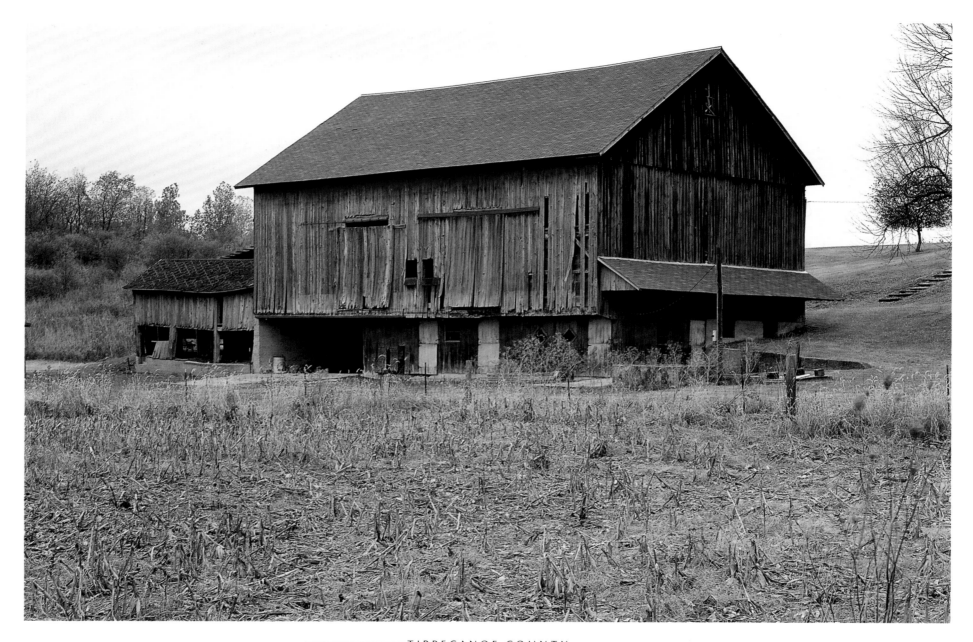

TIPPECANOE COUNTY

*A gable-roofed Pennsylvania bank barn with an
unsupported fore bay, a gable-end pentice
hood, and an equipment shed*

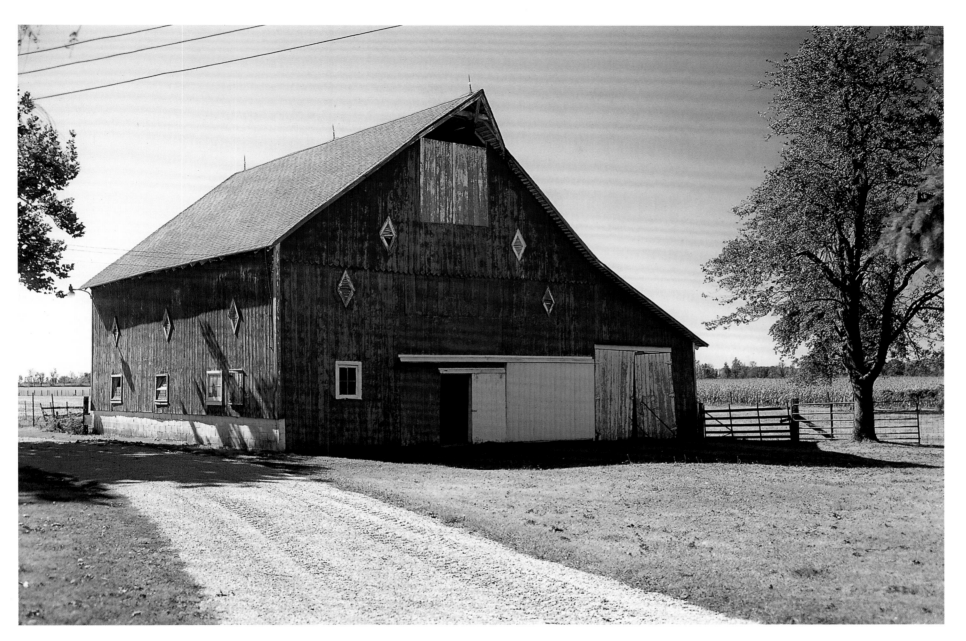

HAMILTON COUNTY

*A gable-roofed transverse frame barn with a shed-roofed
side aisle features a hanging hay hood and
diamond ventilator windows*

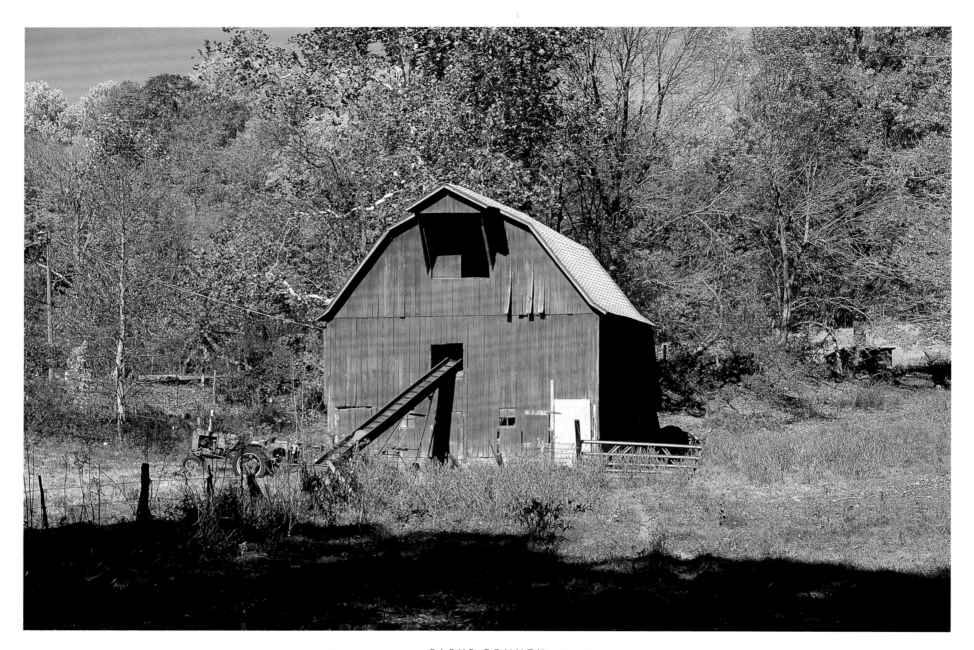

PARKE COUNTY

A gambrel-roofed English barn with a hanging hay hood

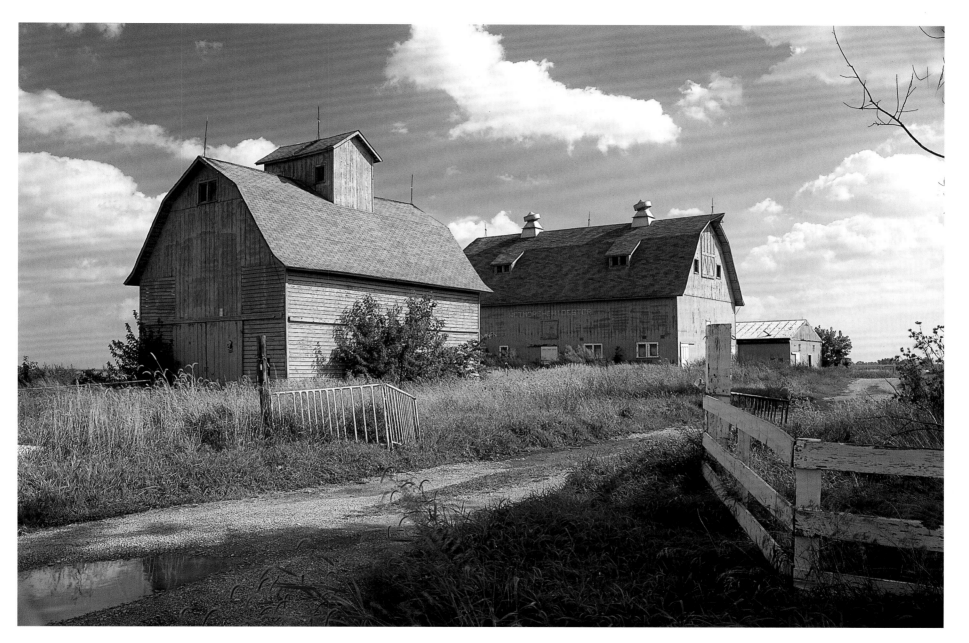

*A farm complex featuring a gambrel-roofed transverse frame crib with
a large cupola, and a gambrel-roofed transverse frame barn
with metal ventilators and shed-roofed ventilation dormers*

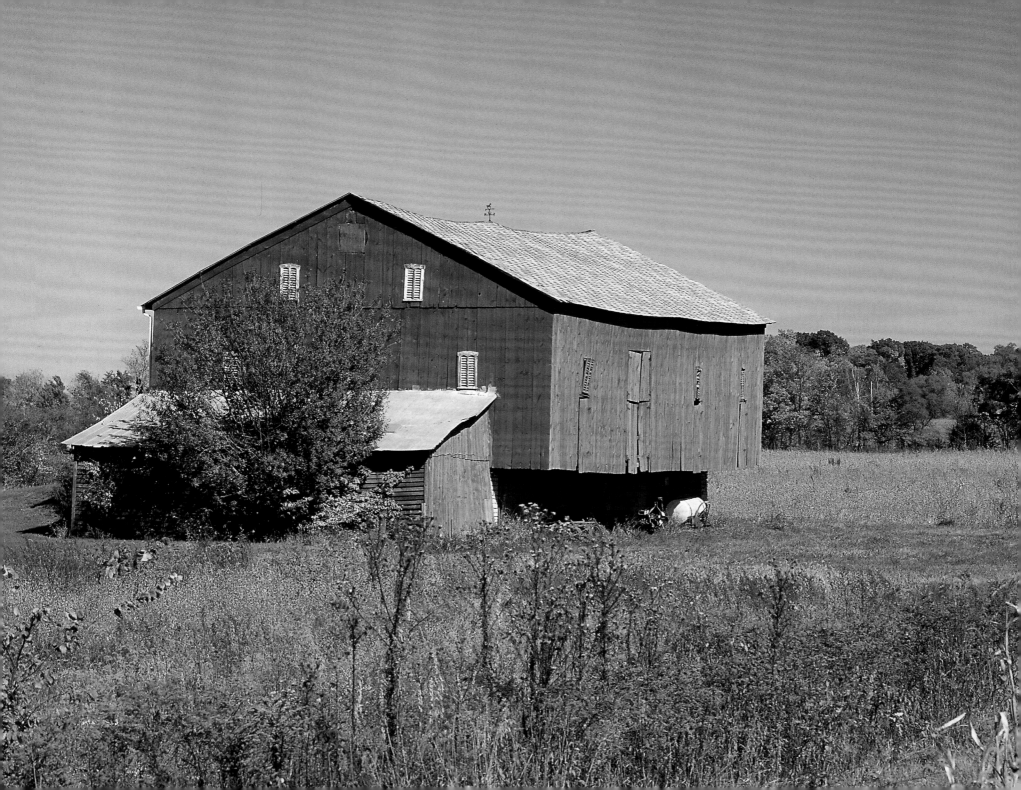

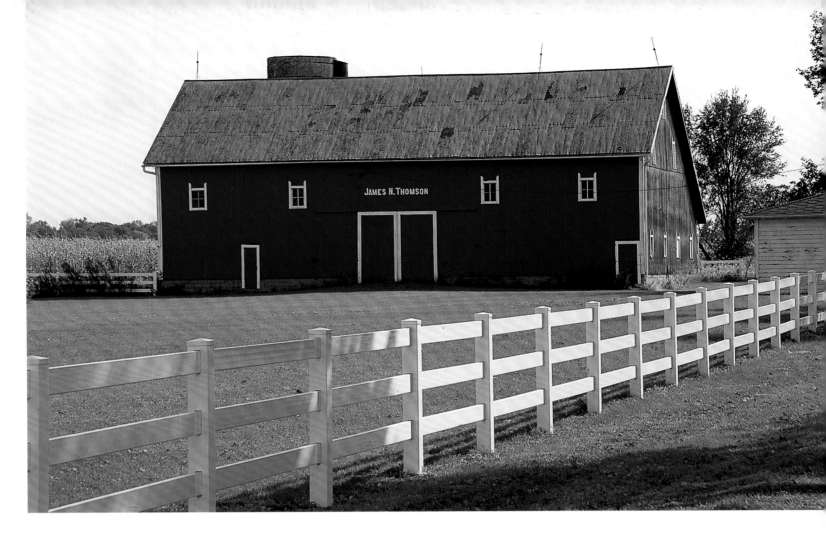

James N. Thomson

—————CARROLL COUNTY—————

*A saltbox-roofed, decorated English barn
featuring painted windows, doors,
and corner posts*

(ABOVE)

—————WELLS COUNTY—————

*A gable-roofed Pennsylvania barn with an
unsupported fore bay and a gable-end
shed-roofed addition*

(FACING)

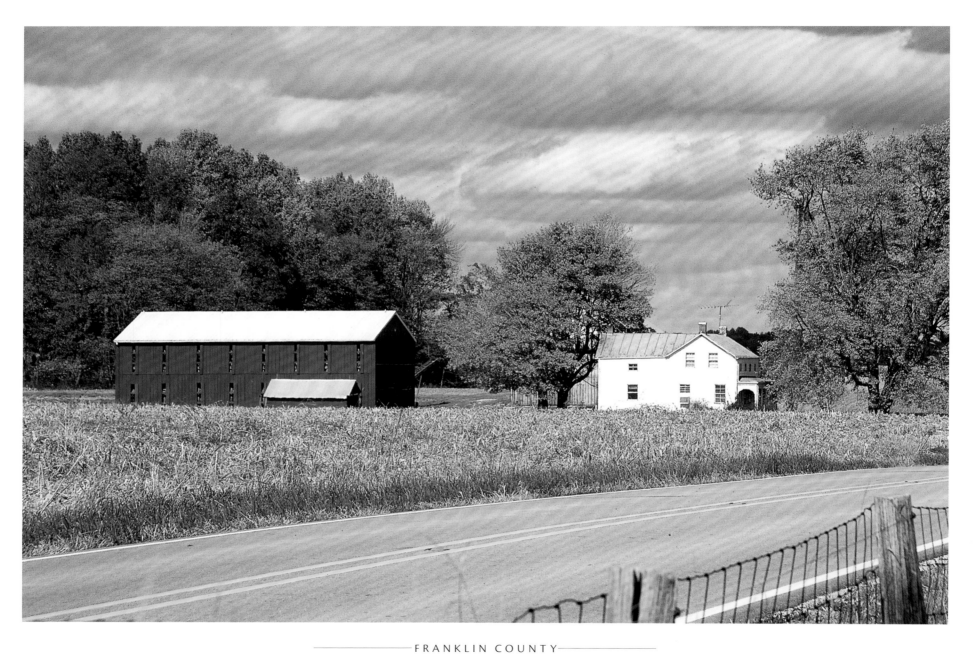

FRANKLIN COUNTY

*A gable-roofed tobacco barn with a
small shed-roofed addition*

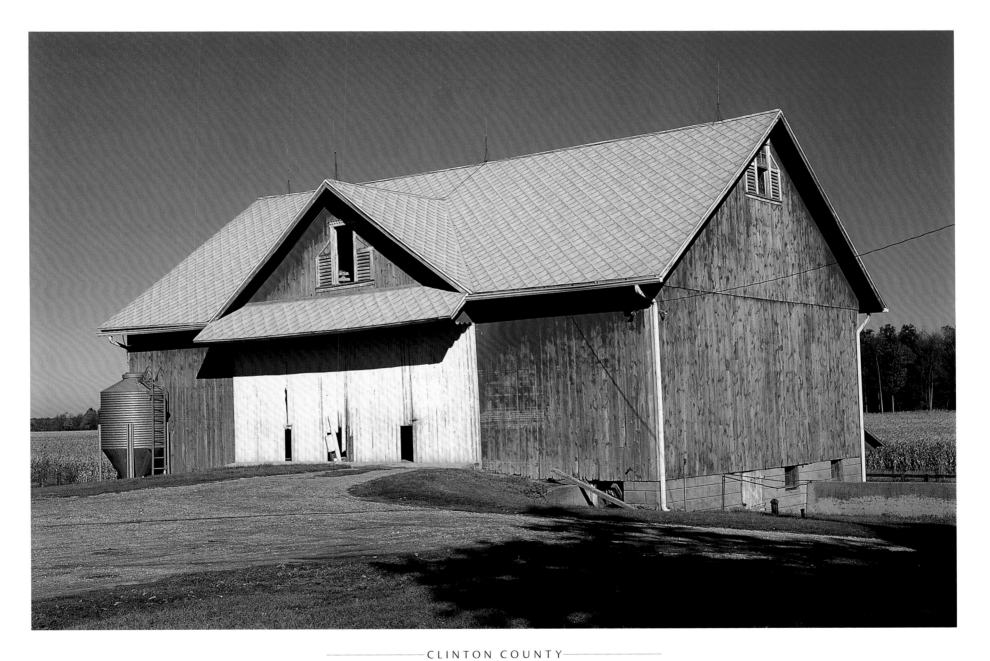

CLINTON COUNTY

*A gable-roofed English bank barn featuring a side-gable
ventilator with a pentice hood below*

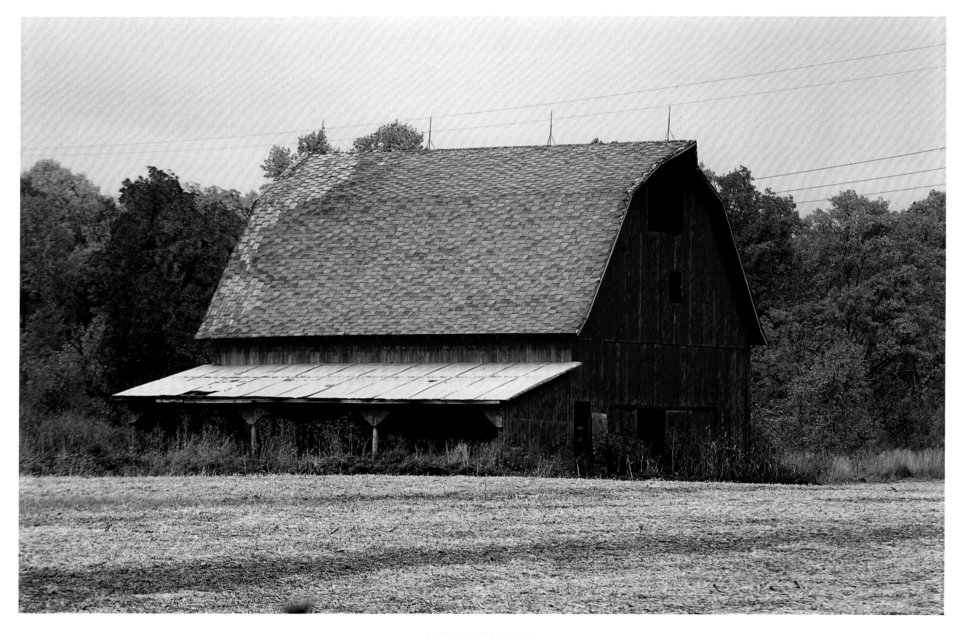

PARKE COUNTY

*A gambrel-roofed transverse frame hay barn
with a shed-roofed equipment
addition and hay hood*

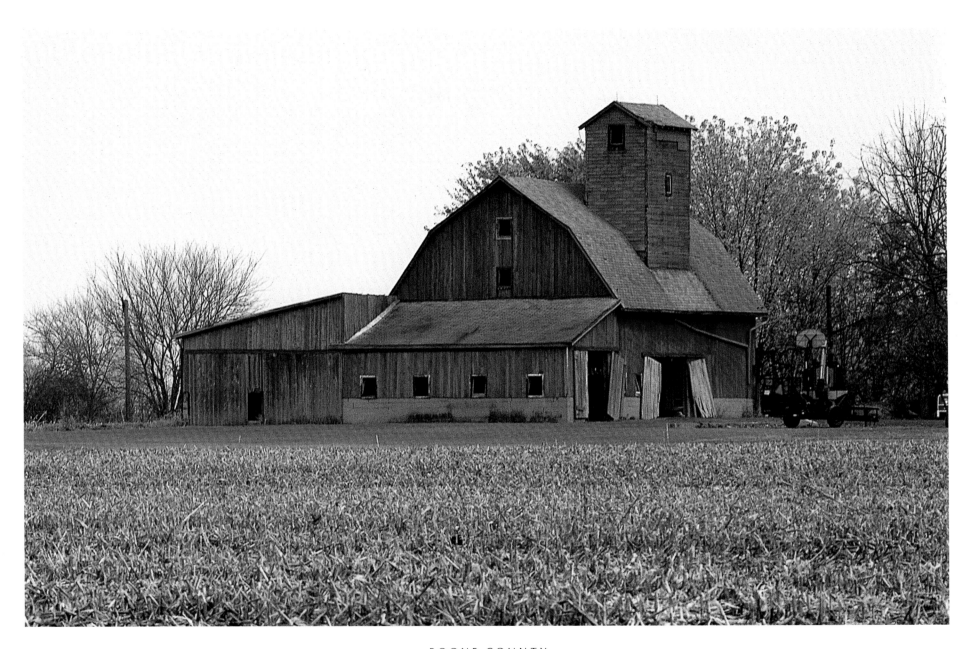

BOONE COUNTY

*A gambrel-roofed English barn with a granary
and two shed-roofed additions*

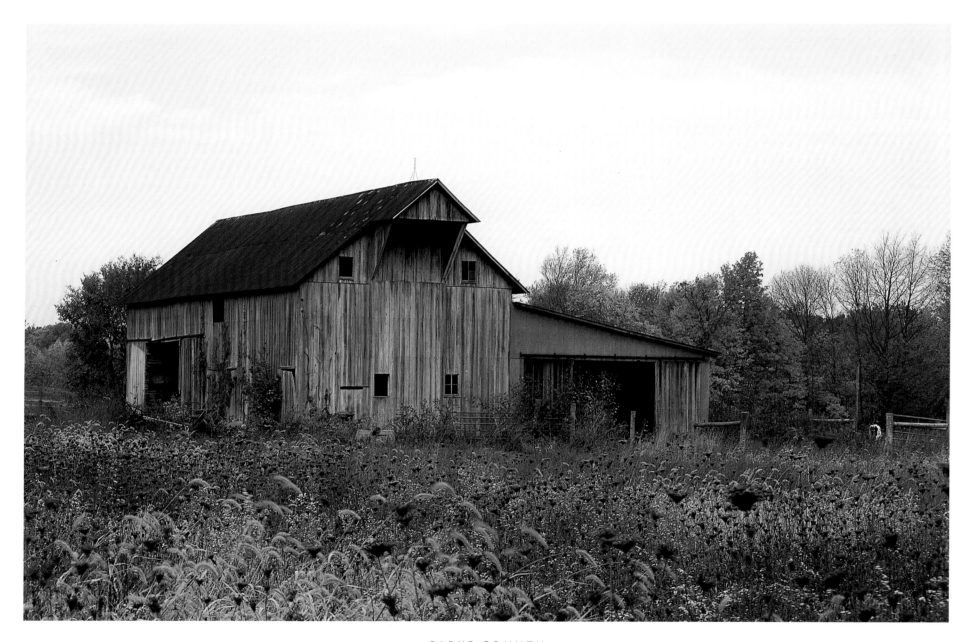

PARKE COUNTY

*A gable-roofed English barn with an equipment shed
addition and hay hood*

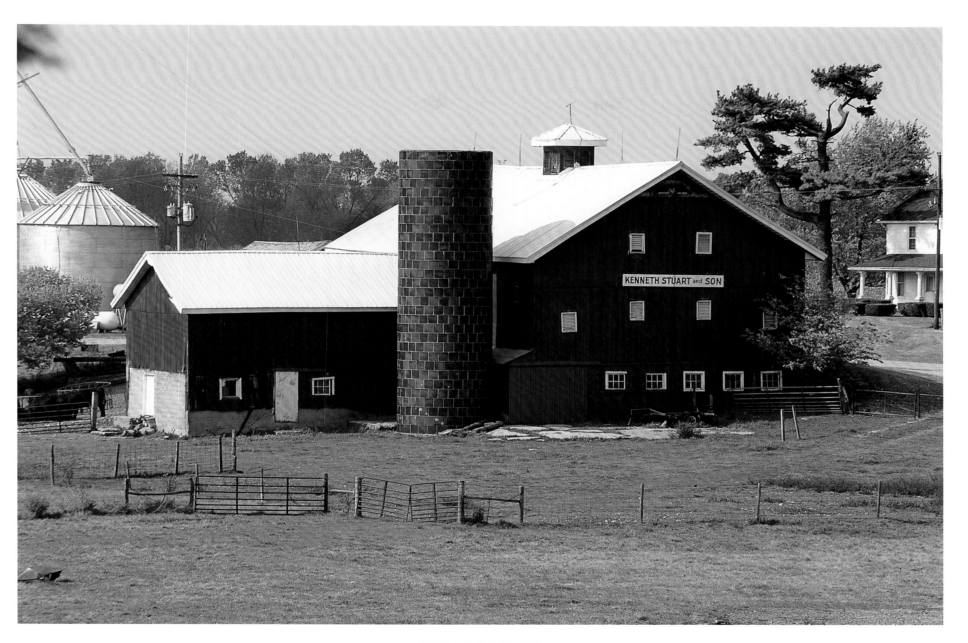

KENNETH STUART and SON

WAYNE COUNTY

*A gable-roofed English hay and livestock barn with a
rear gable-roofed addition, a ventilator cupola,
and a terracotta silo*

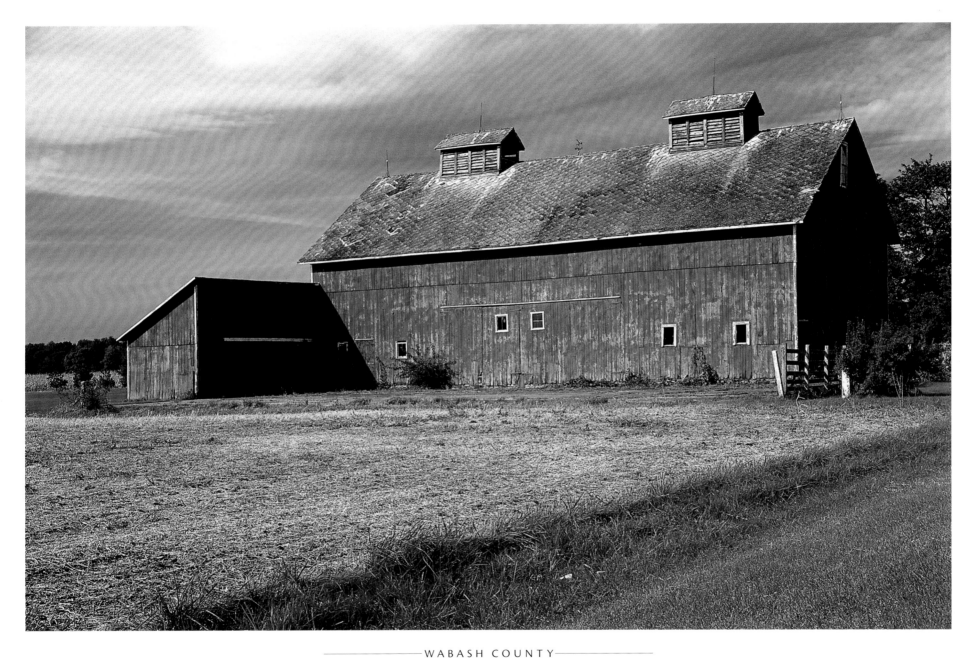

WABASH COUNTY

A gable-roofed English barn with two louvered
ventilator cupolas and an adjoining shed

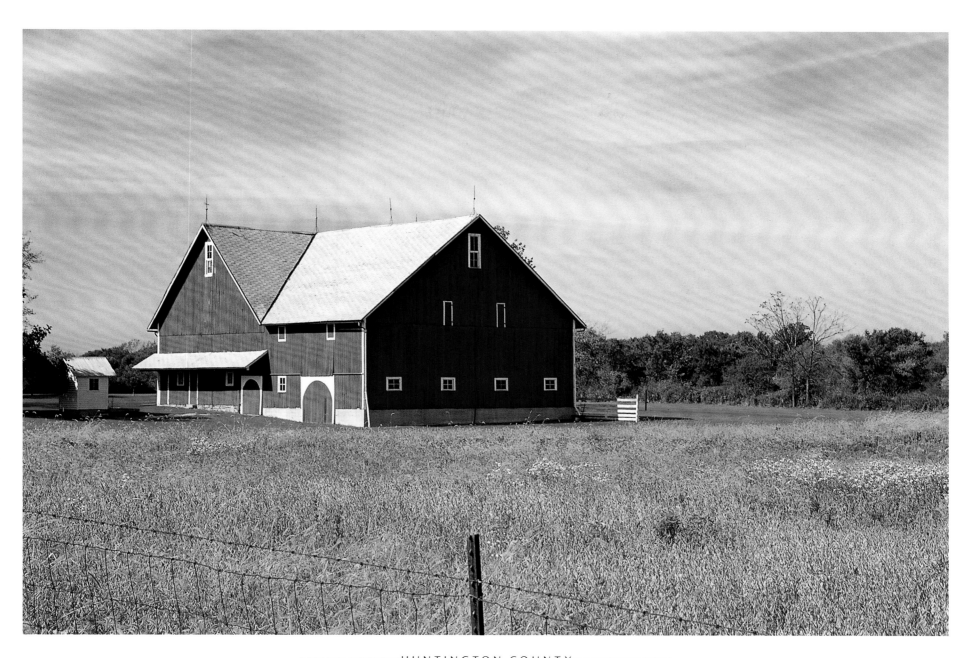

HUNTINGTON COUNTY

*A three-end foundation barn with a pentice roof
features decorated, painted arched doors*

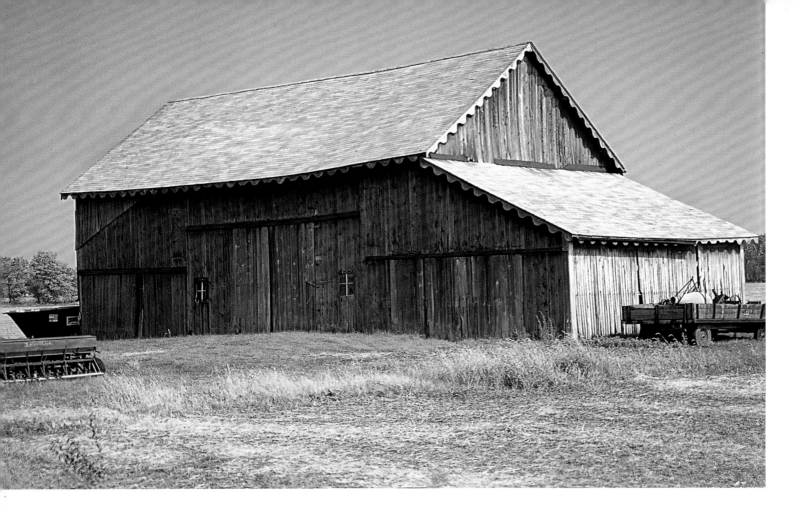

WAYNE COUNTY

*A gable-roofed English barn with a
shed-roofed gable-end addition features
decorative verge boards*

(ABOVE)

FRANKLIN COUNTY

*A transverse frame tobacco barn
with a gable roof*

(FACING)

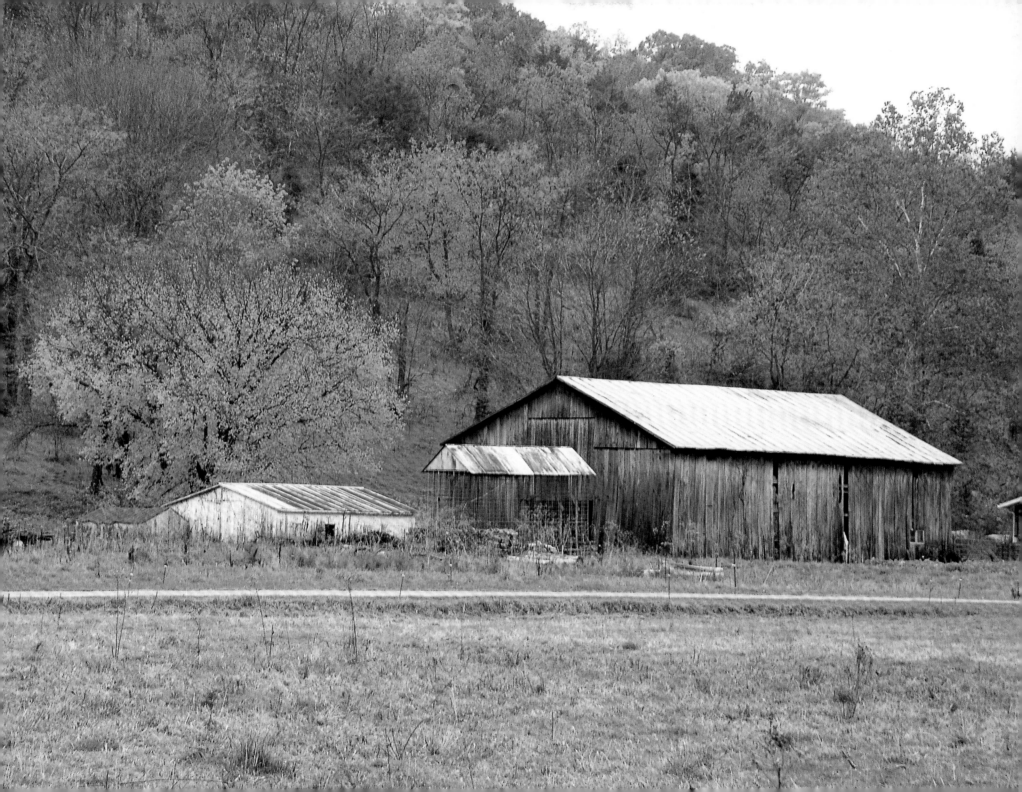

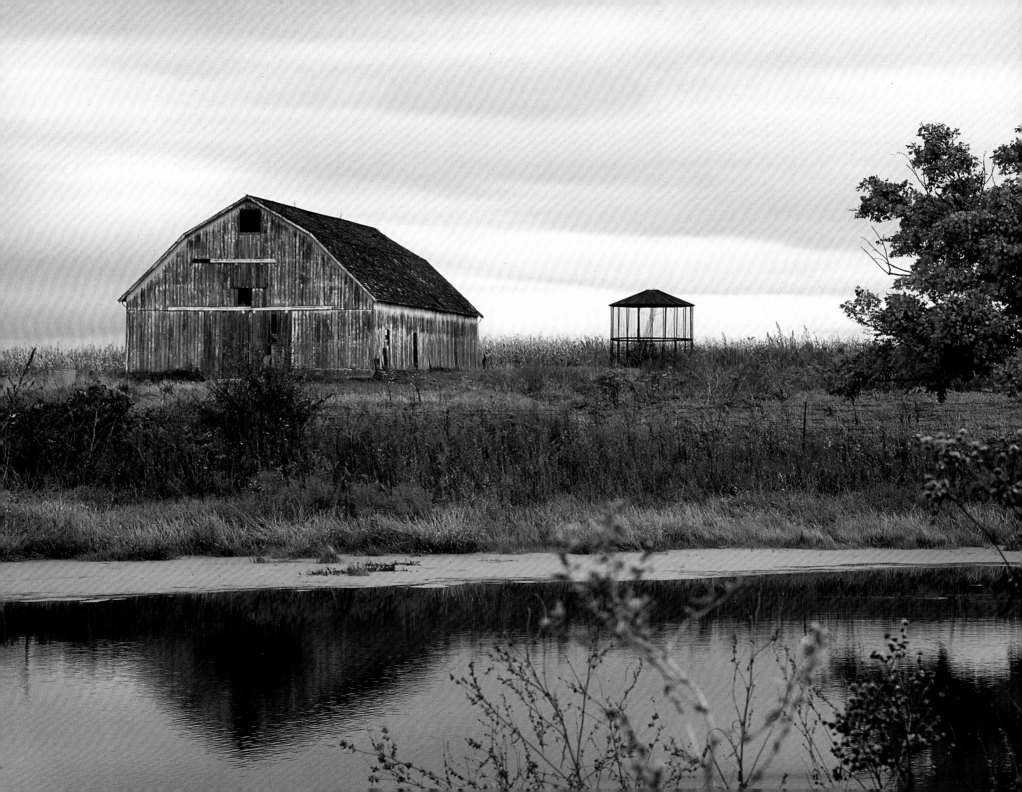

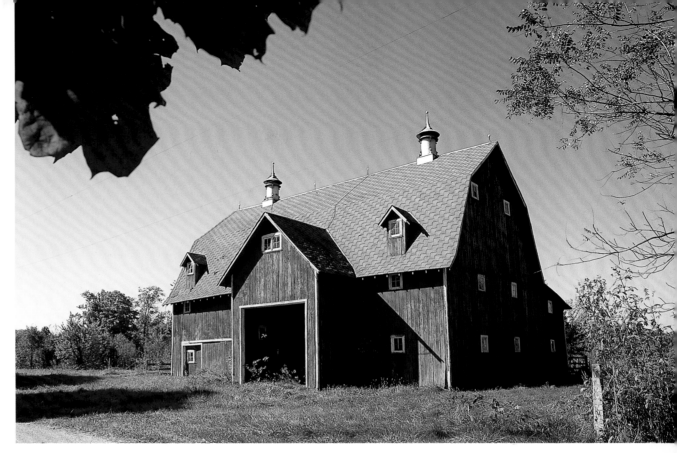

—FULTON COUNTY—

*A gambrel-roofed English barn with a projecting
gabled entry porch and a rear shed-roofed
addition features metal ventilators
and ventilation dormers*

(ABOVE)

—FRANKLIN COUNTY—

*A transverse frame barn with a
gambrel roof*

(FACING)

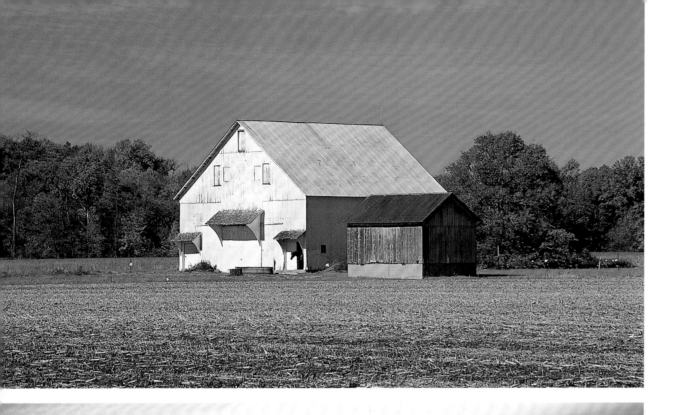

PARKE COUNTY

*A gable-roofed transverse frame barn
featuring three pentice-roofed
gable-end entries*

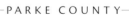

PARKE COUNTY

A Dutch barn with two gable-end additions

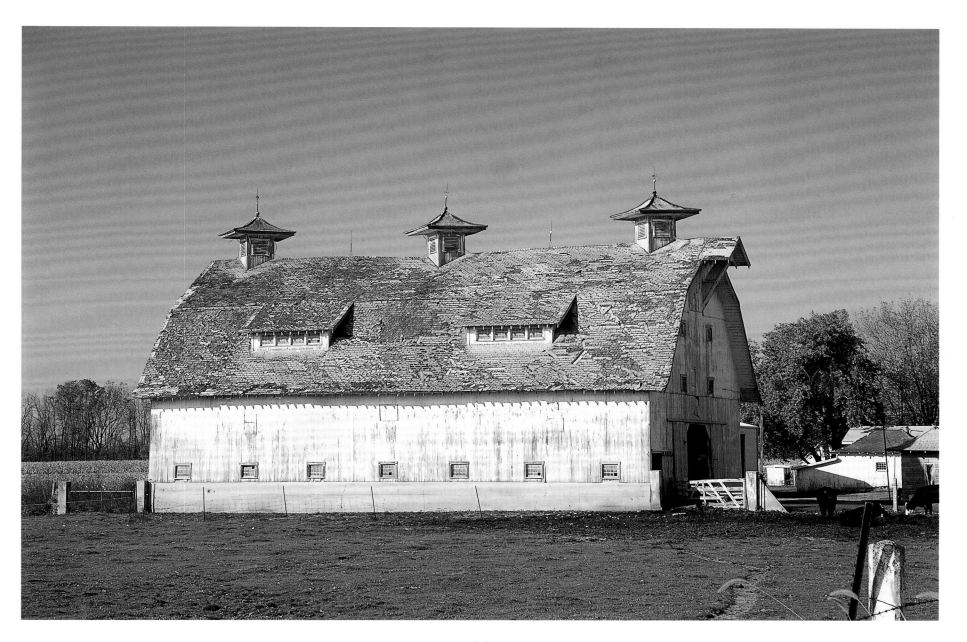

RUSH COUNTY

A gambrel-roofed transverse frame dairy barn features
pagoda-roofed ventilator cupolas, shed-roofed
ventilation dormers, and a hay hood

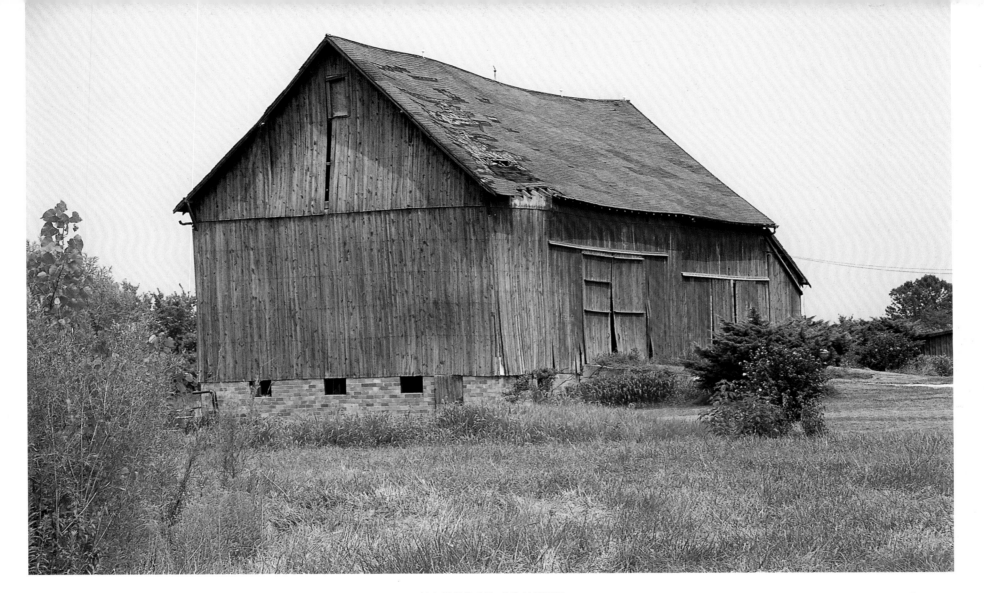

—————————— HANCOCK COUNTY ——————————

*A gable-roofed English bank barn with a raised ceramic
brick foundation and a shed-roofed addition
on the gable end*

(ABOVE)

—————————— WABASH COUNTY ——————————

*A gable-roofed English bank barn with decorative
verge boards and Victorian roof ventilators*

(FACING)

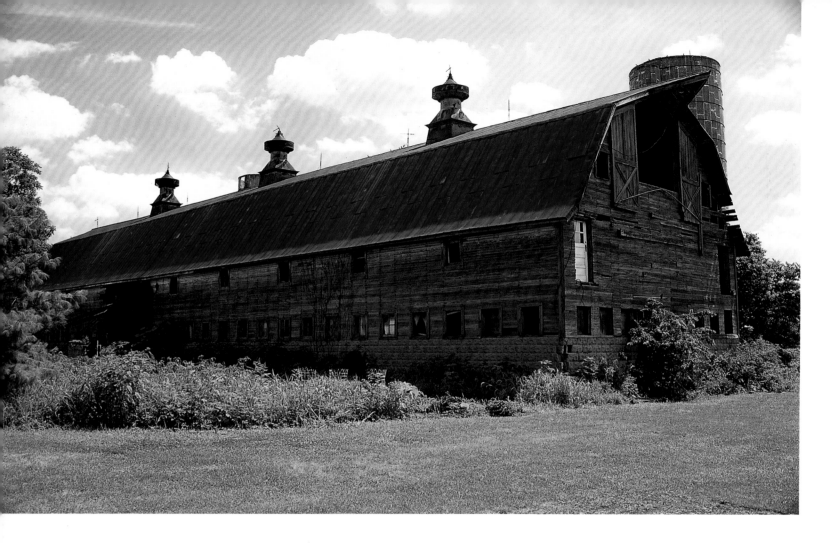

———TIPPECANOE COUNTY———

*A large, gambrel-roofed Wisconsin dairy barn
with a decorative concrete block foundation,
metal ventilators, and a hay hood*

(ABOVE)

———PUTNAM COUNTY———

*A decorated gable-roofed transverse
frame barn with shed-roofed
side additions*

(FACING)

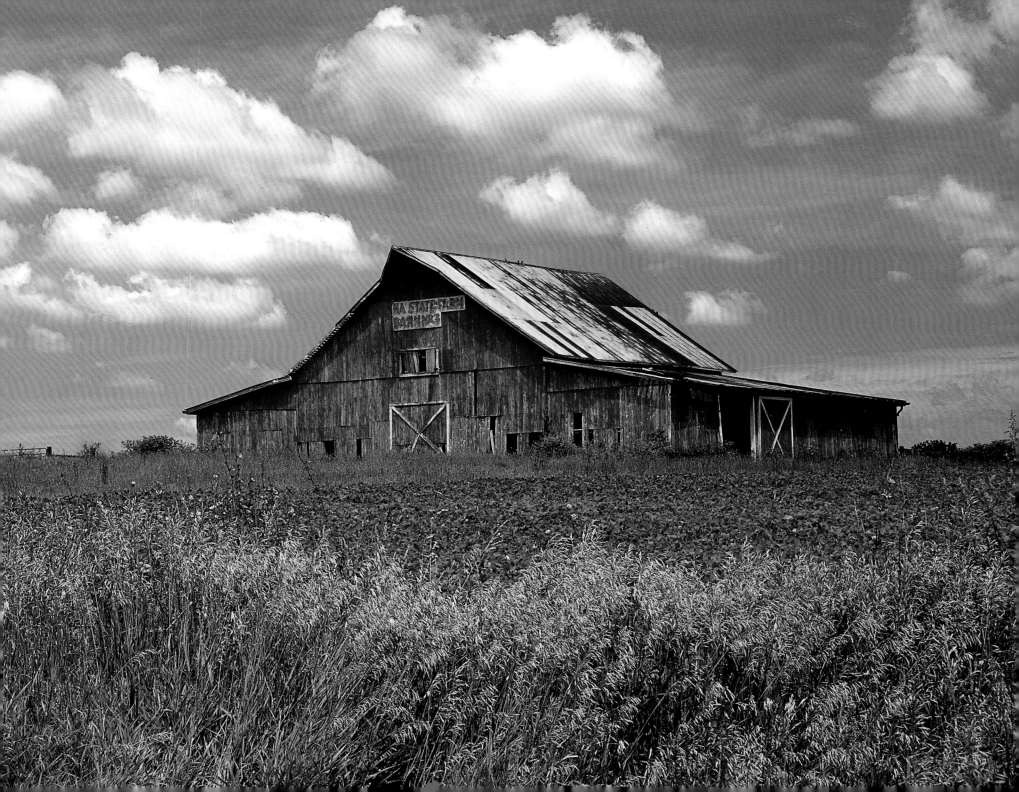

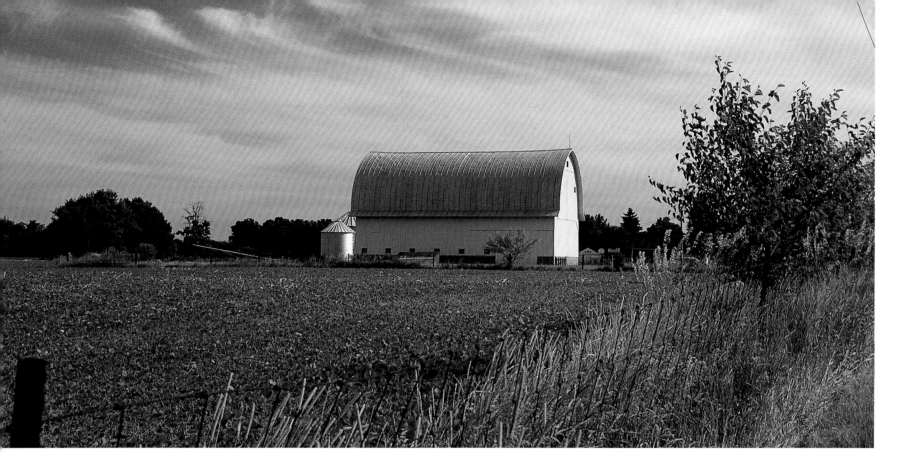

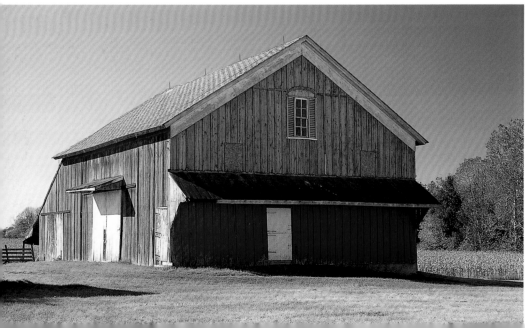

———CASS COUNTY———

A helmet-roofed hay and livestock foundation barn

(ABOVE)

———CLINTON COUNTY———

A gable-roofed English barn with a gable-end shed-roofed addition and decorative verge boards also features a pentice hood on the opposite gable end and a pentice roof over the entry

(LEFT)

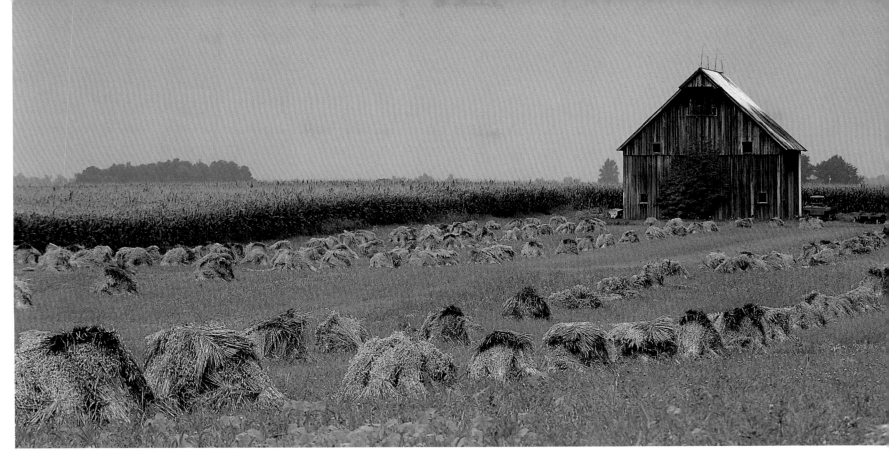

HAMILTON COUNTY

*A gable-roofed English barn
with a hanging gable*

(ABOVE)

CLINTON COUNTY

*A gambrel-roofed foundation barn
with a hanging gable*

(RIGHT)

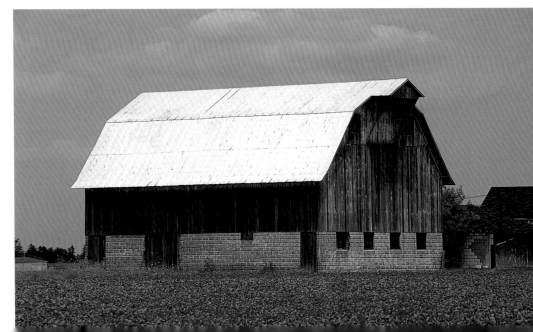

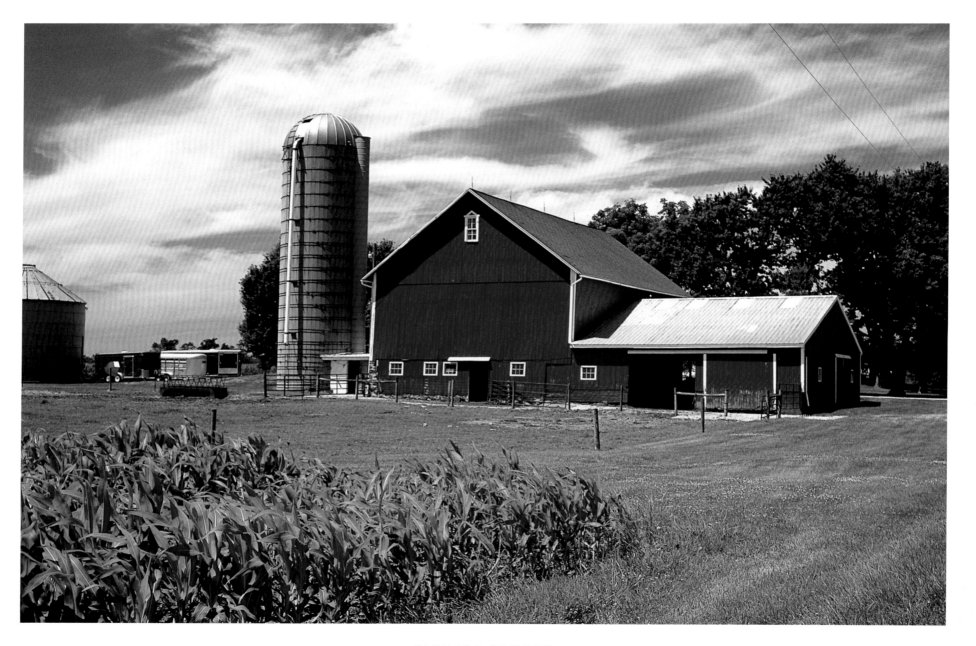

ELKHART COUNTY

*A gable-roofed English barn with a
gable-roofed addition*

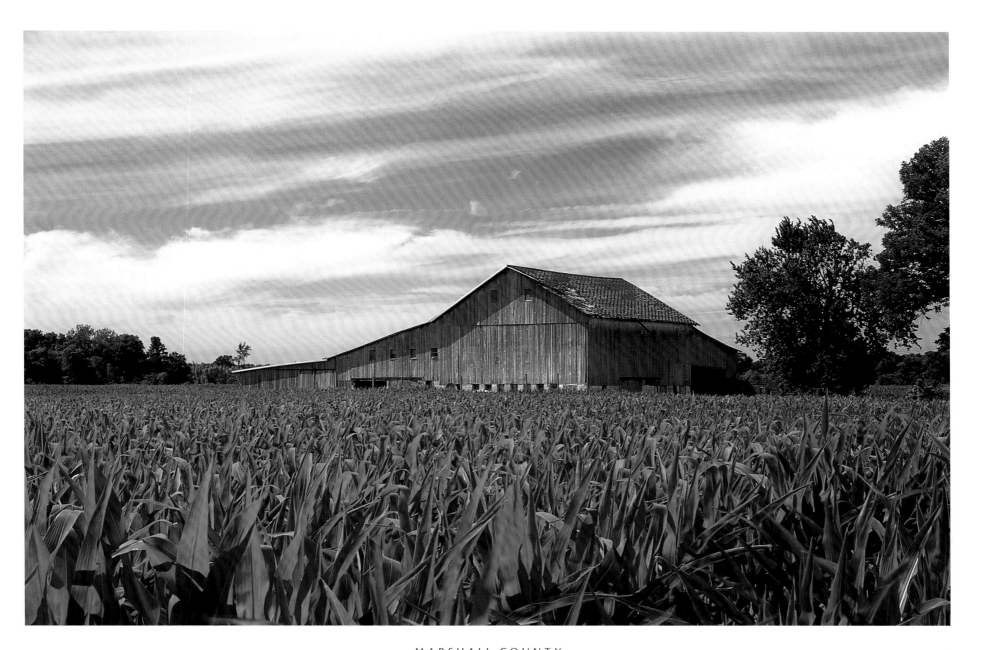

MARSHALL COUNTY

*A gable-roofed English barn with extended
shed-roofed additions*

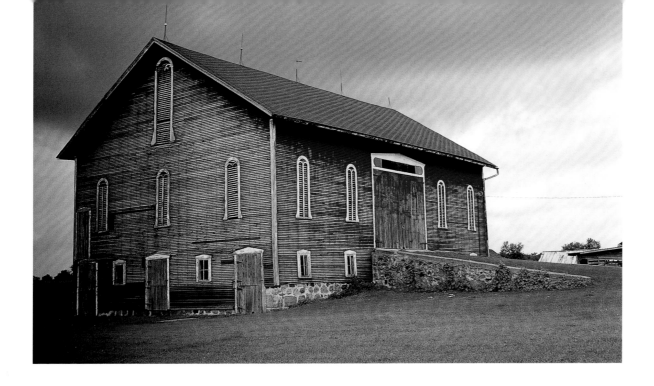

FULTON COUNTY

A gable-roofed, decorated English bank barn features decorative louvered ventilation windows, gable-end pedimented Dutch doors, clapboard siding, and a transom light over the main entry

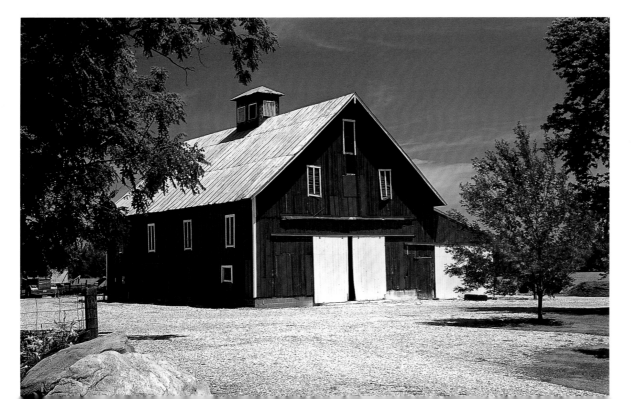

BOONE COUNTY

A gable-roofed transverse frame decorated barn with a shed-roofed side aisle features a ventilator cupola and louvered ventilator windows

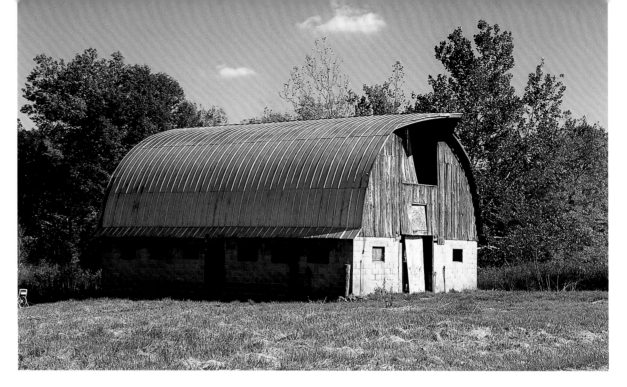

A round-roofed transverse foundation barn with a hay hood

MIAMI COUNTY

A gambrel-roofed transverse frame barn with clapboard siding, a shed-roofed side aisle, and a gabled connection to a ceramic-tile silo

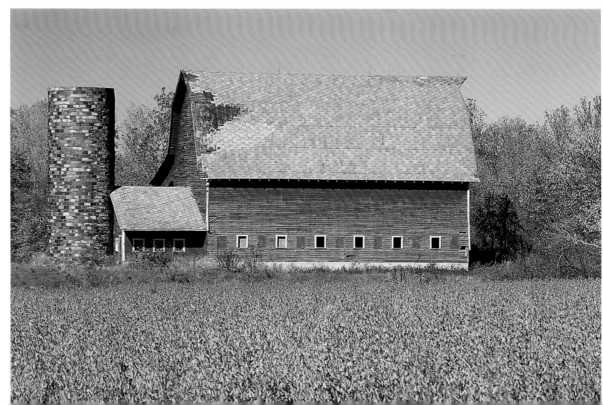

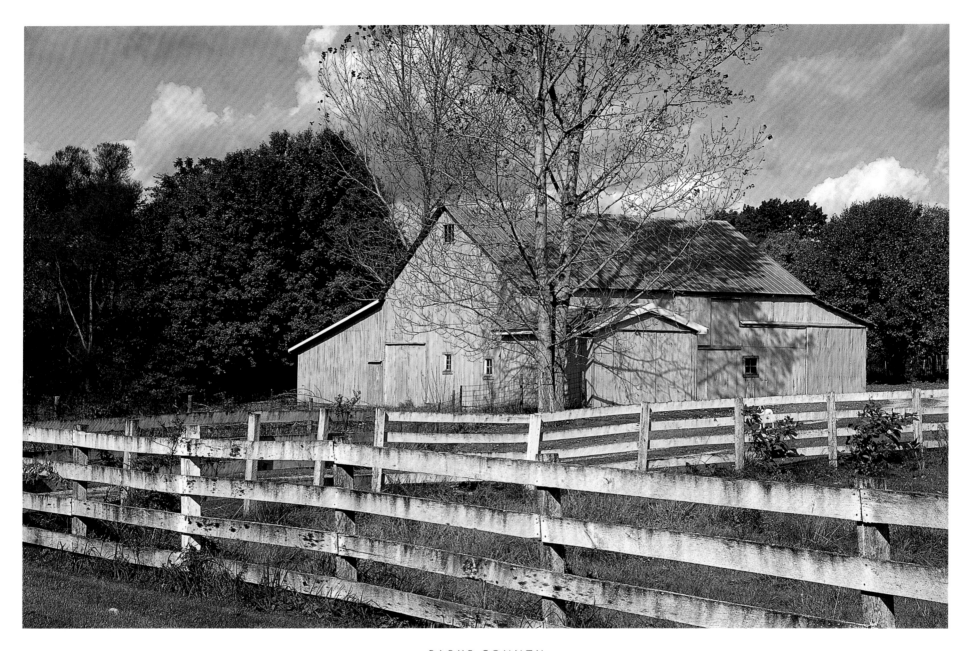

PARKE COUNTY

*A gable-roofed English barn with shed- and
gable-roofed additions*

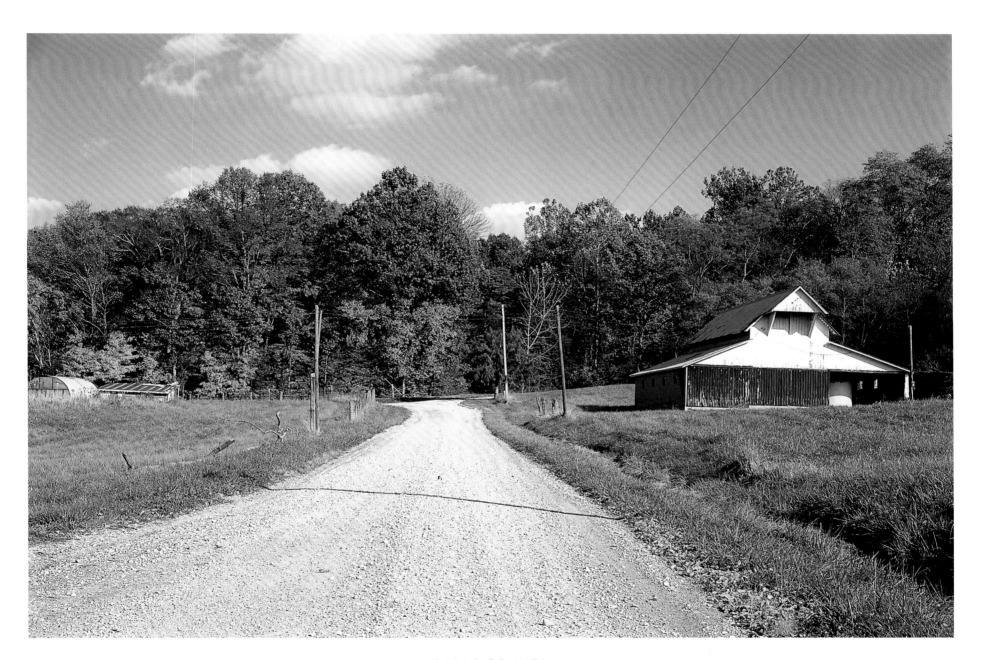

PARKE COUNTY

A gable-roofed transverse frame barn
with shed-roofed side aisles
and a hanging gable

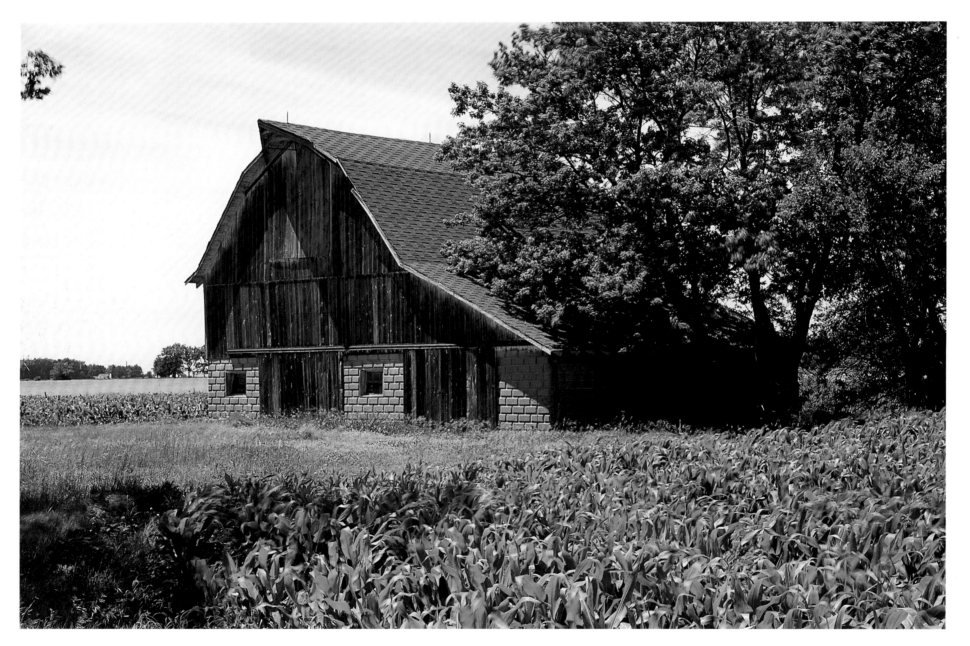

BOONE COUNTY

A gambrel-roofed transverse frame foundation barn
with a shed-roofed side aisle and hay hood

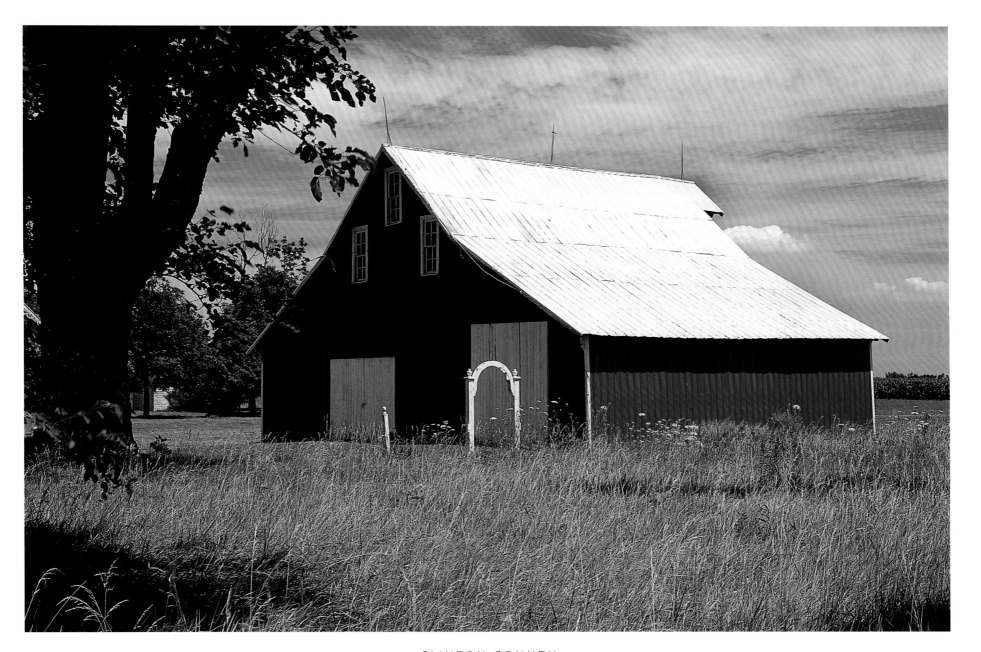

A transverse frame barn with a broken-gable roof,
a hay hood, and a unique ventilator
window configuration

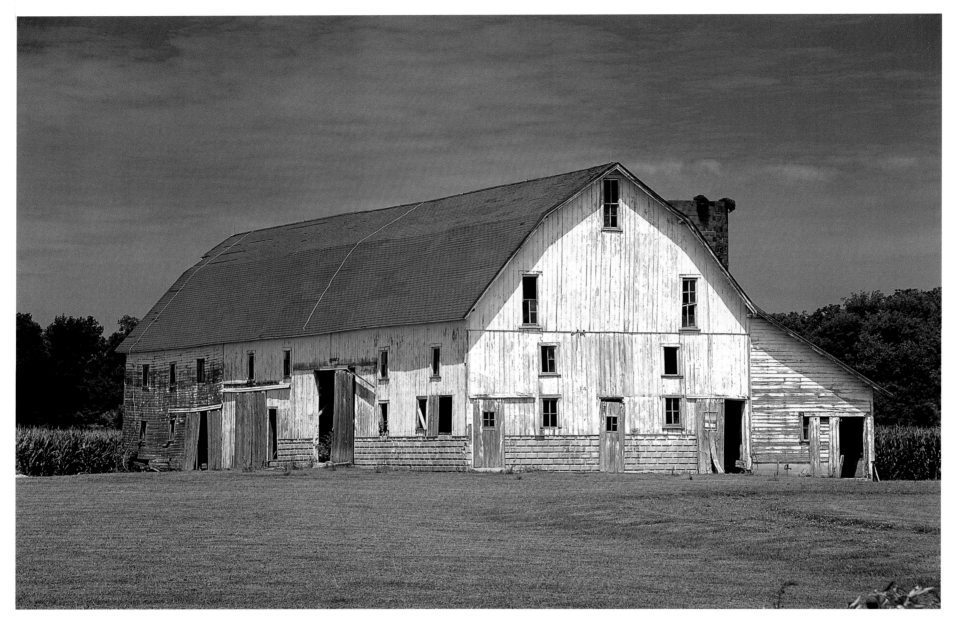

CLINTON COUNTY

A gambrel-roofed foundation barn
with a shed-roofed addition

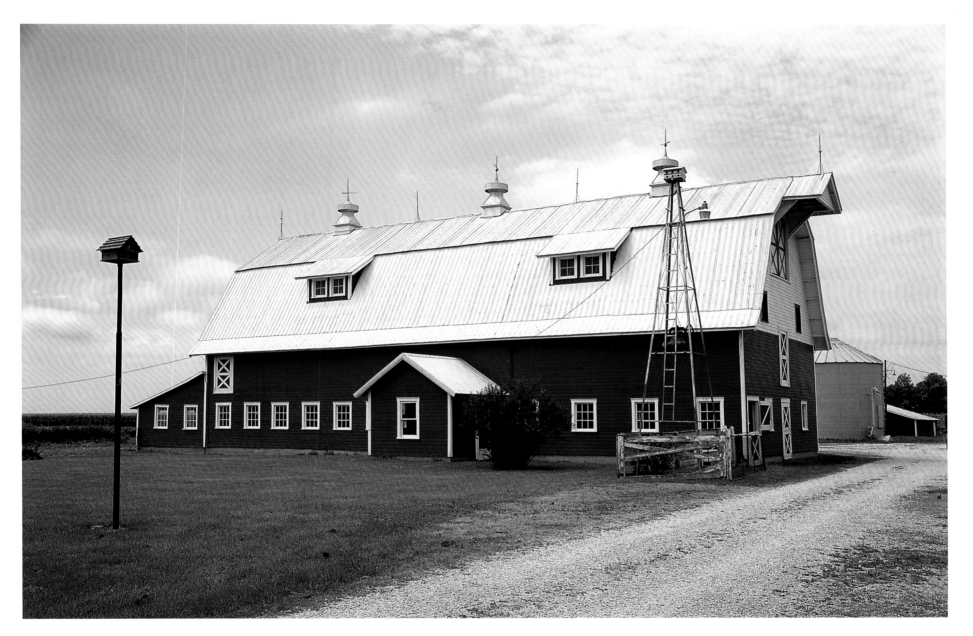

MIAMI COUNTY

*A gambrel-roofed Wisconsin dairy barn with a gable-end
shed-roofed addition and a small gabled side addition
features metal ventilators, shed roof ventilation
dormers, and a hanging gable*

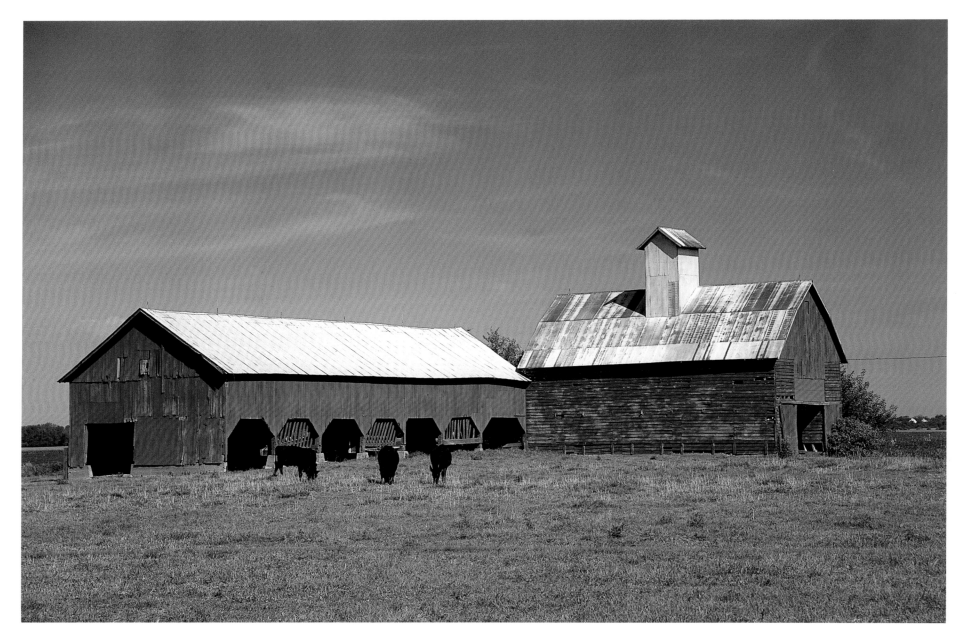

JASPER COUNTY

A farm complex featuring a gable-roofed
transverse crib barn with a granary and
a gable-roofed livestock shed

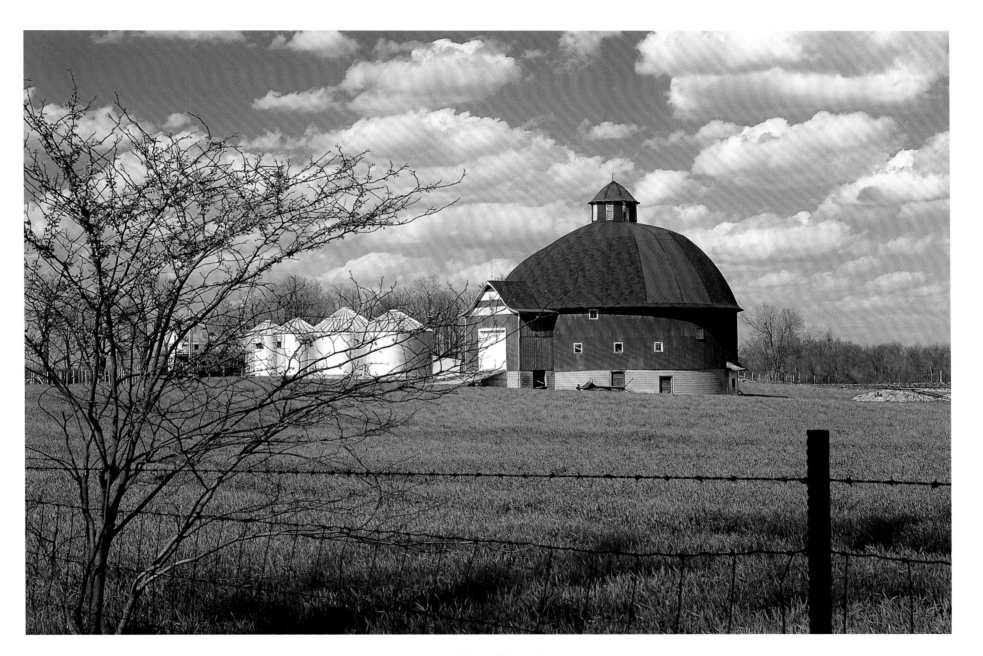

─────── CLINTON COUNTY ───────

*A round foundation barn with a dome roof, a round ventilator
cupola, and a barn bridge to a broken-gable
projecting entry porch*

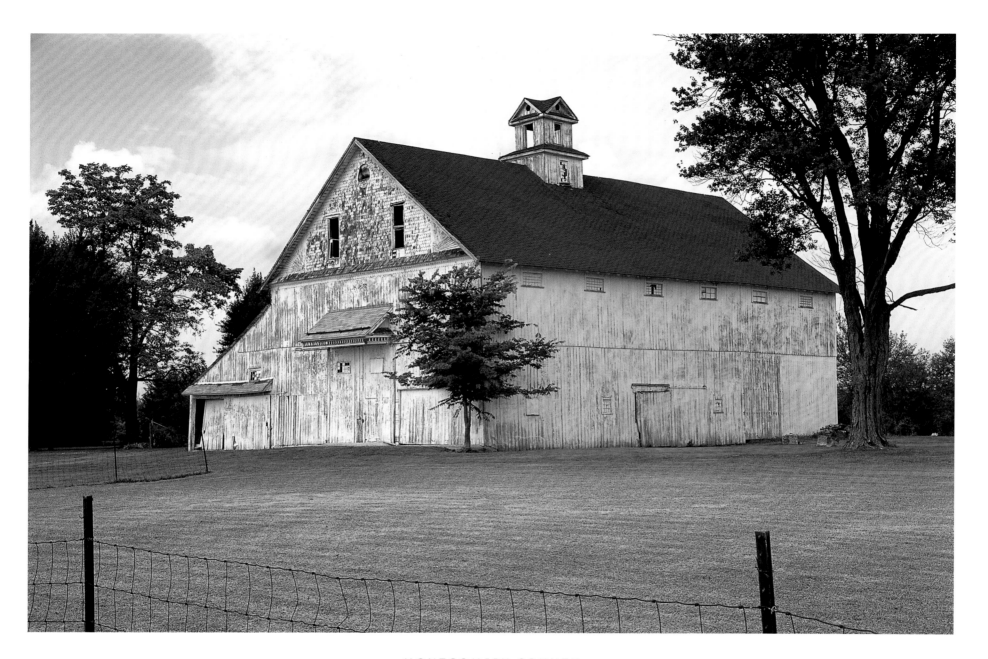

MONTGOMERY COUNTY

*A gable-roofed transverse frame barn with a shed-roofed addition; both the main structure
and the addition have gable-end pentice roofs, the larger featuring spool-work detail;
the main roof features a temple form, cross-gabled cupola ventilator*

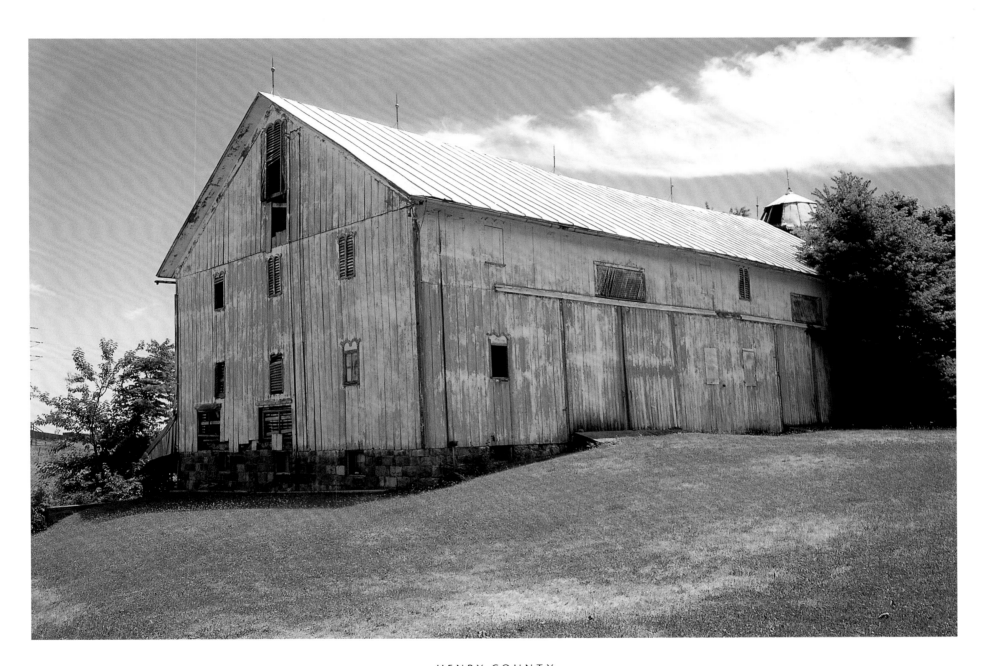

HENRY COUNTY

*A gable-roofed English bank barn with a raised stone foundation
features double-arched, louvered ventilator windows*

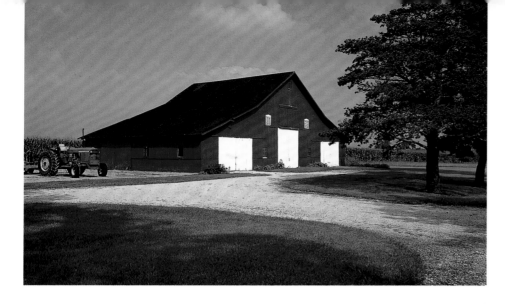

———MONTGOMERY COUNTY———

A broken-gable transverse frame barn

(LEFT)

———HENRY COUNTY———

*A transverse frame barn with a gable roof and
decorative louvered ventilators*

(BELOW)

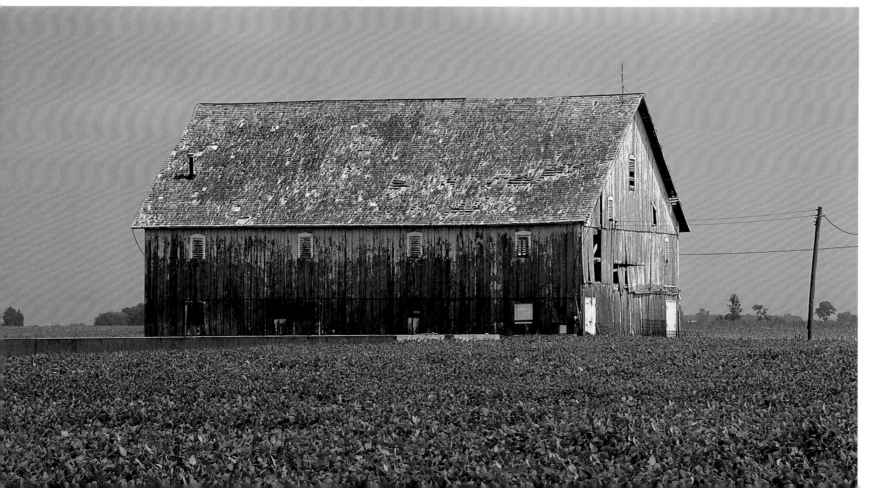

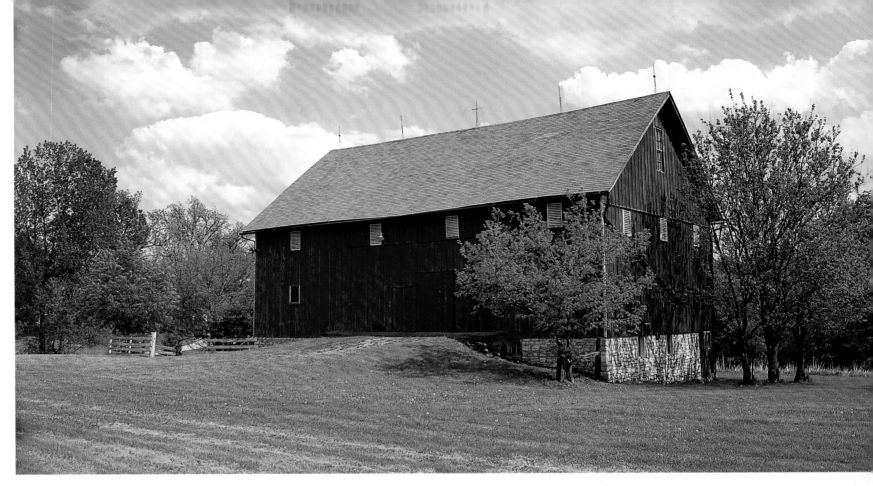

CARROLL COUNTY

A gable-roofed English bank barn with a raised stone foundation features louvered ventilation windows

(ABOVE)

WARREN COUNTY

A transverse frame barn with a broken-gable roof and battened siding features a hay hood

(RIGHT)

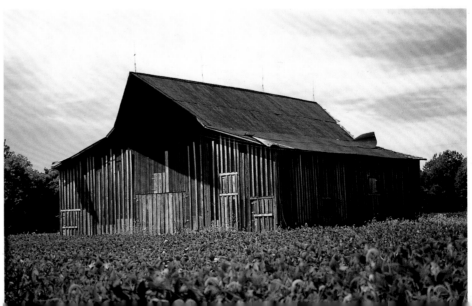

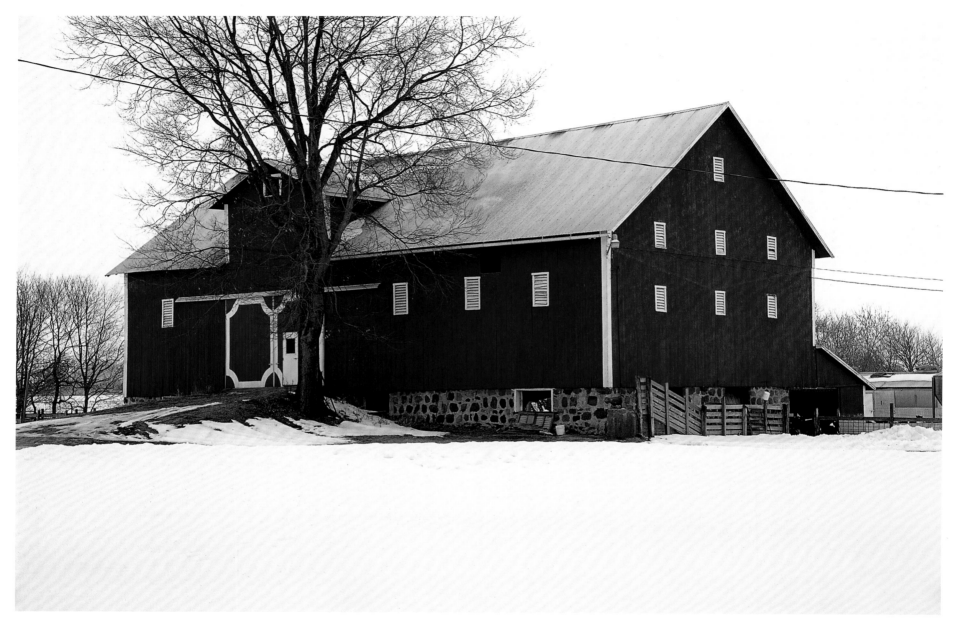

CARROLL COUNTY

*A gable-roofed bank barn with a raised fieldstone
foundation features a side gable
and decorative doors*

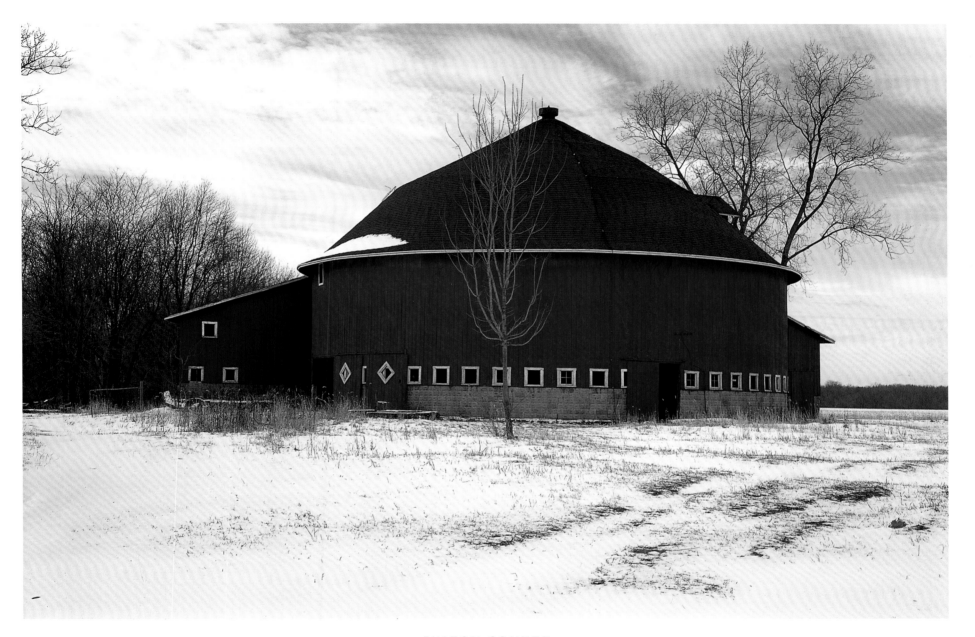

FULTON COUNTY

A round foundation barn with two shed-roofed additions
has a multiple-pitch, conical roof and features a
metal ventilator, a gabled dormer, and
decorative diamond-shaped windows

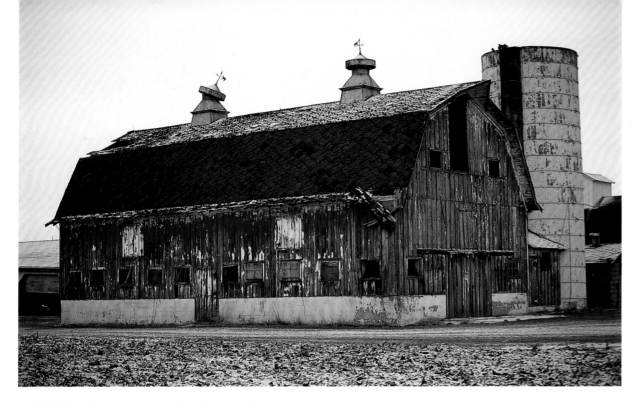

PORTER COUNTY

A gambrel-roofed Wisconsin dairy barn with a concrete foundation features a gabled connection to a concrete silo, metal ventilators, and a hay hood

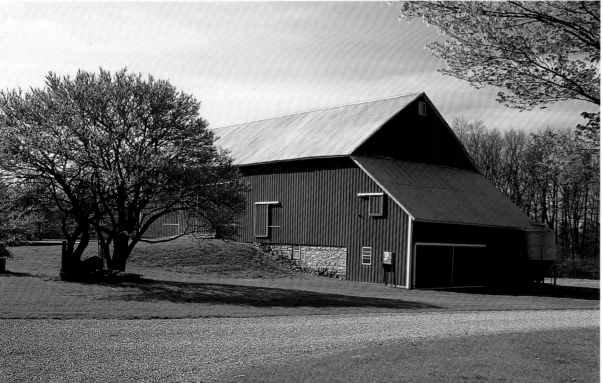

ALLEN COUNTY

A gable-roofed English bank barn features a raised stone foundation and a shed-roofed gable-end addition

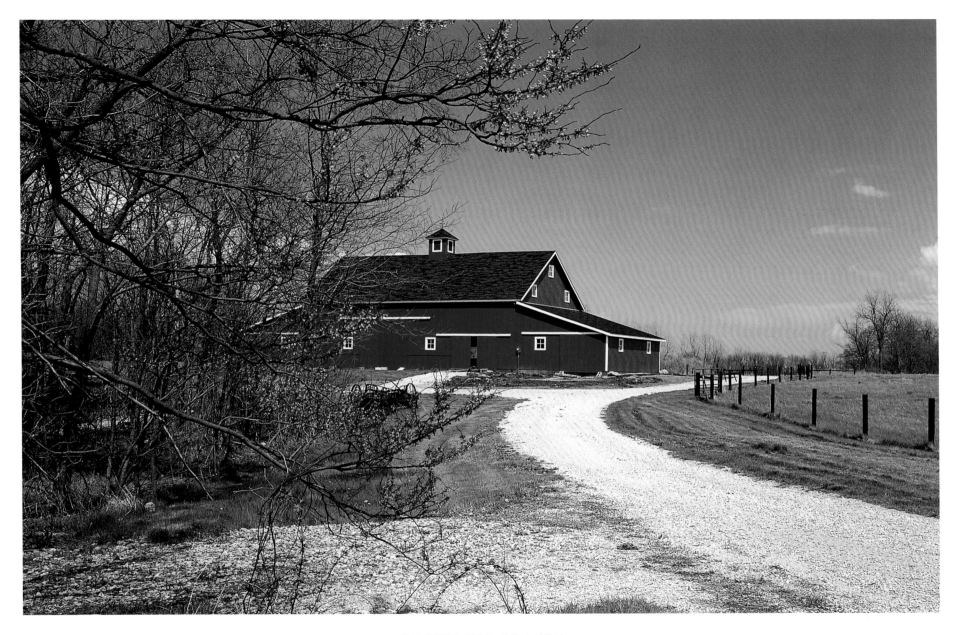

TIPPECANOE COUNTY

*A gable-roofed English barn with two equipment
shed additions features a cupola ventilator*

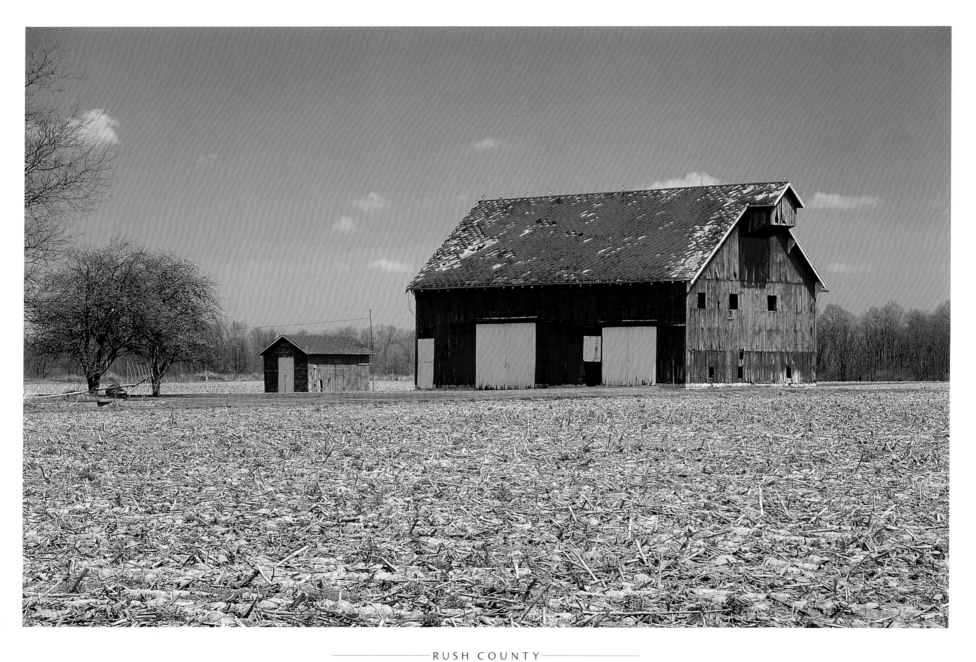

RUSH COUNTY

*A gable-roofed English barn
with a hanging gable*

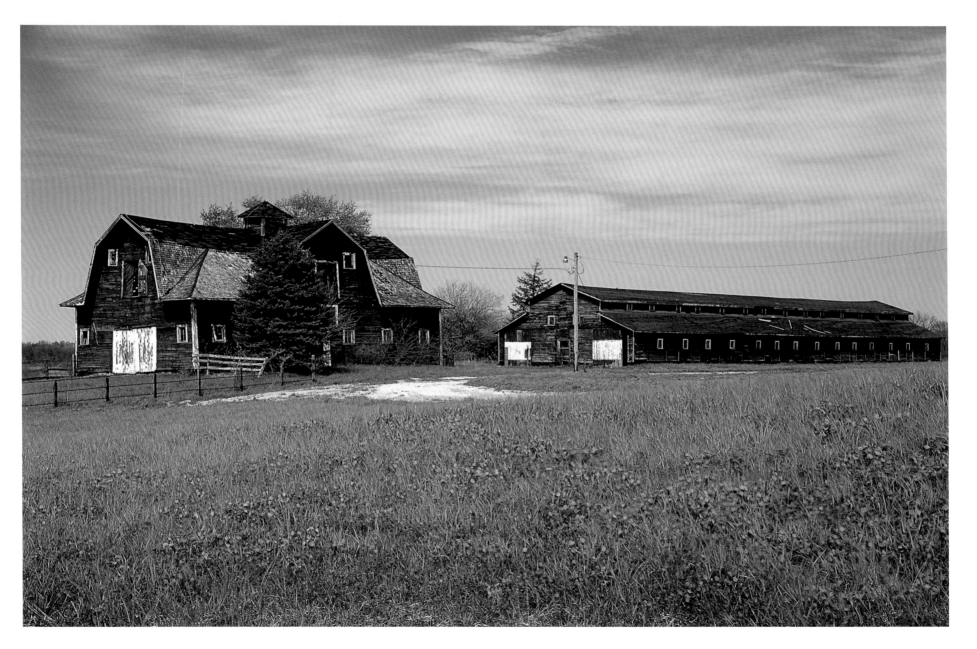

*A farm complex featuring a cross-gambrel roof barn with a
ventilator cupola and a long, clerestory poultry house*

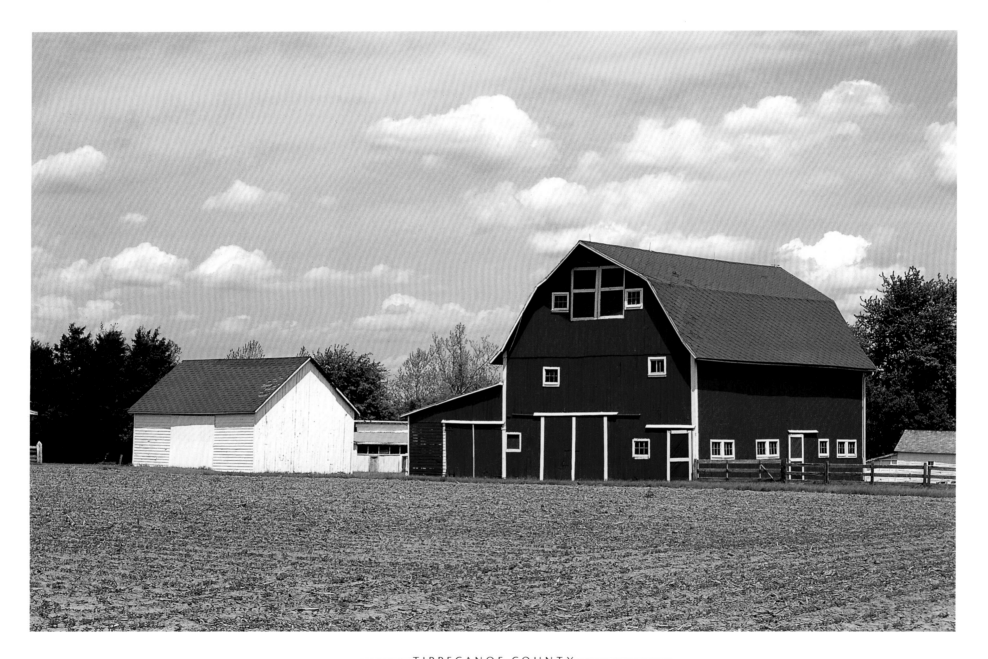

TIPPECANOE COUNTY

*A farm complex featuring a gambrel-roofed transverse
frame barn with an equipment shed addition*

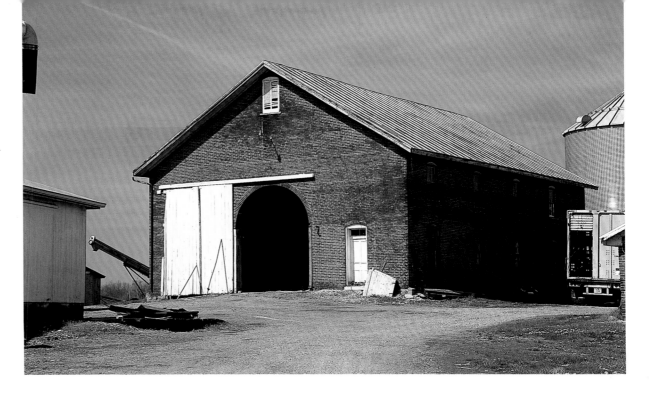

WAYNE COUNTY

A gable-roofed, central-aisle, brick barn features a large Romanesque arched entrance and decorative arched windows

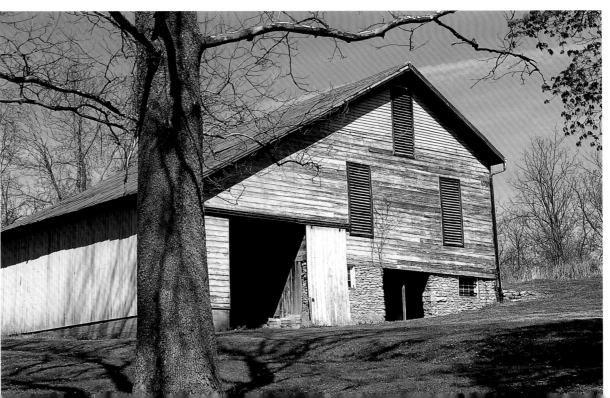

WAYNE COUNTY

An English bank barn with a raised fieldstone foundation and an asymmetrical gable; it features large louvered gable-end vents and horizontal clapboard siding

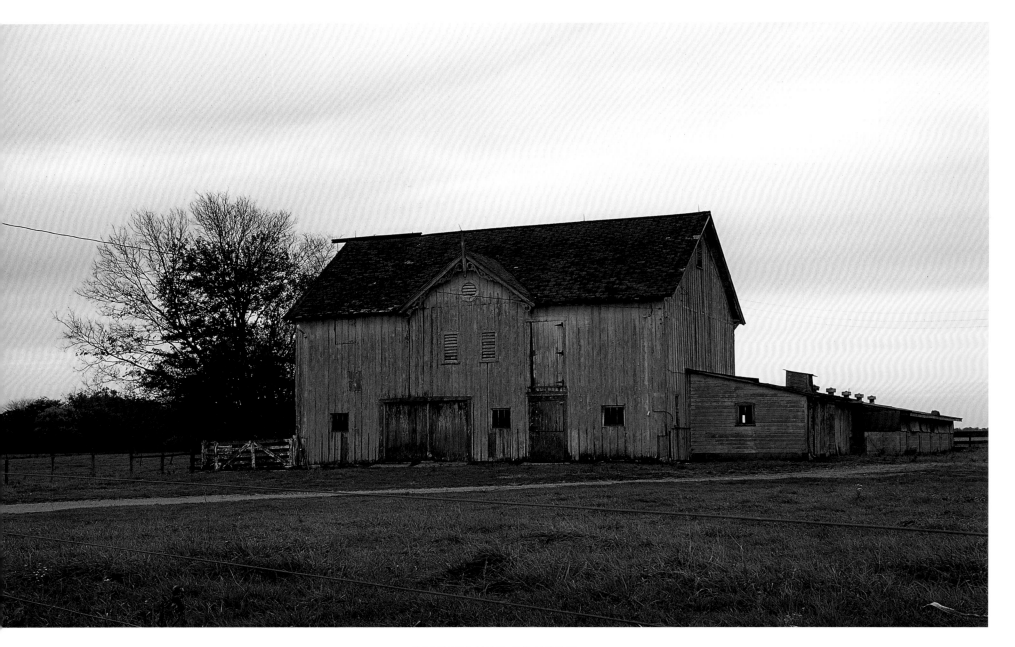

*A gable-roofed English barn with a shed addition features
a decorative side gable with Victorian scrollwork*

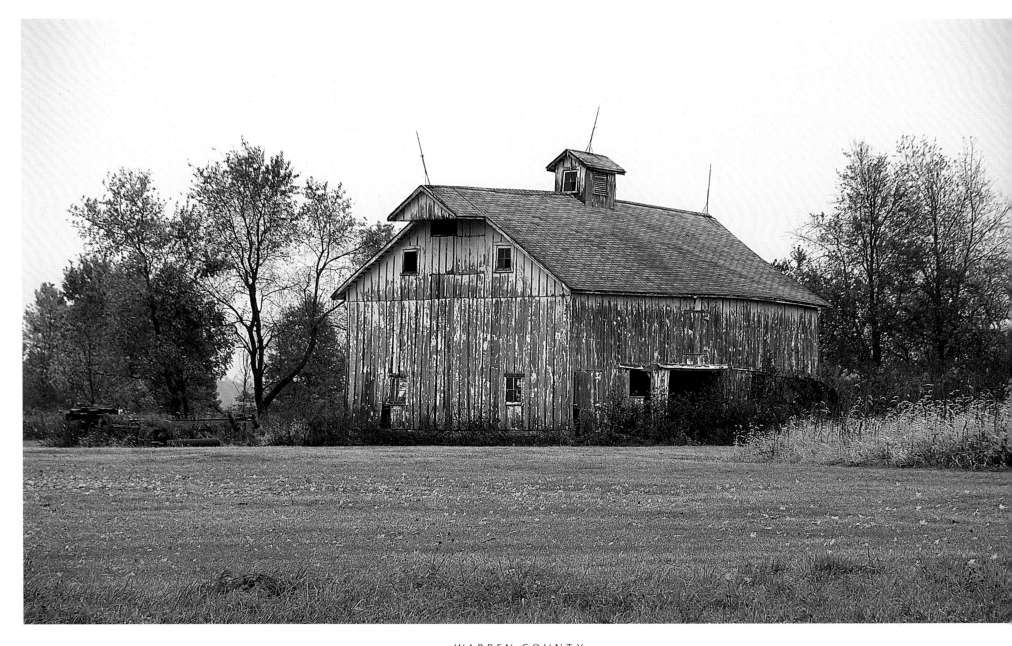

WARREN COUNTY

*A gable-roofed English barn with a hanging
gable and a ventilator cupola*

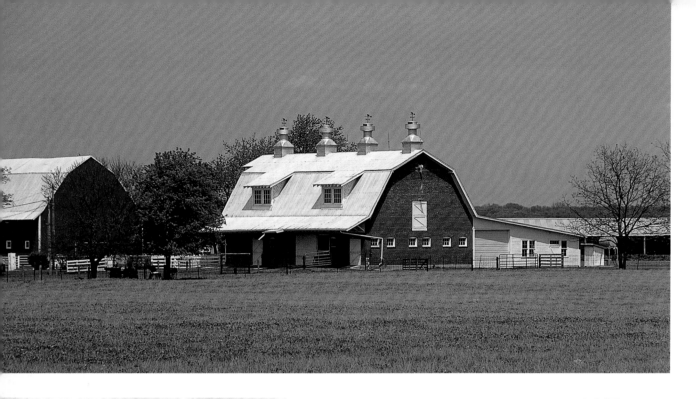

A farm complex featuring a brick, gambrel-roofed English barn with a large shed-roofed addition has four large metal ventilators, shed roof dormers, and a pentice roof over the entrance

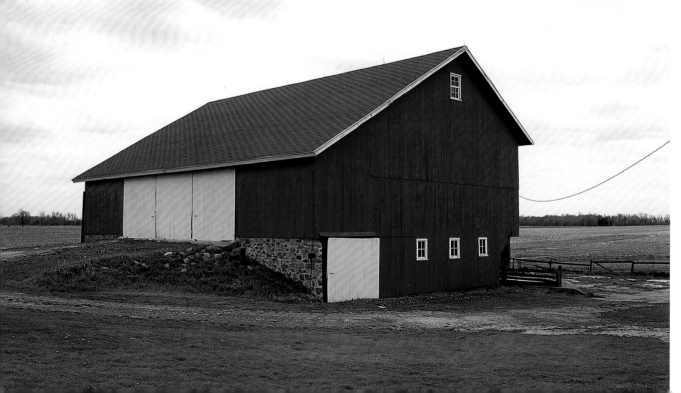

CLINTON COUNTY

An asymmetrical gable-roofed Pennsylvania bank barn with an unsupported fore bay

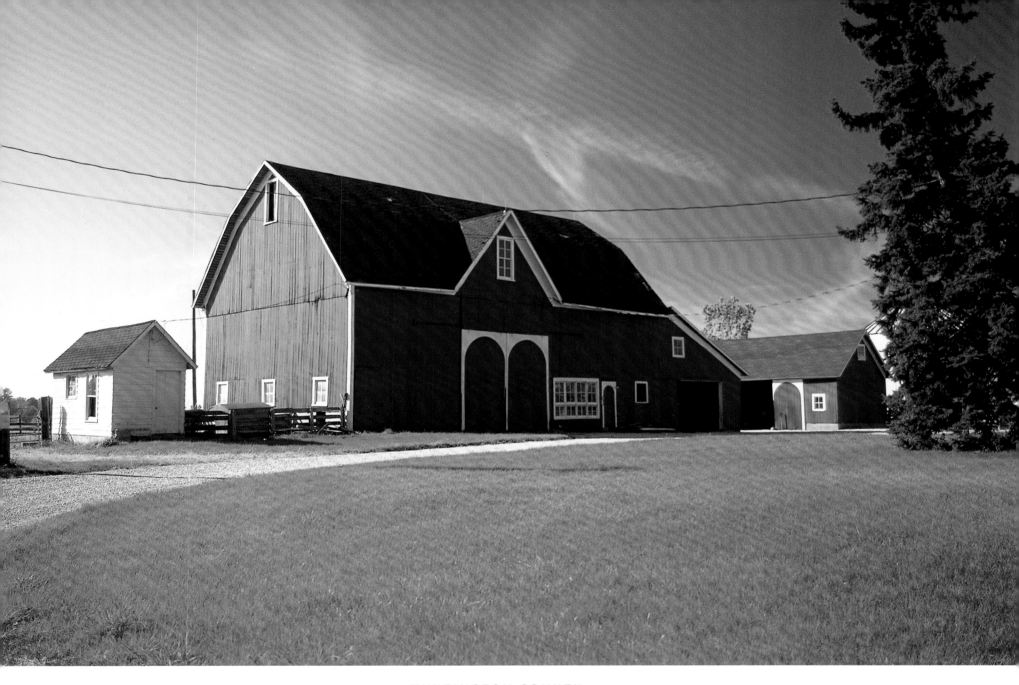

A farm complex featuring a gambrel-roofed decorated
English barn with a shed-roofed addition has painted
arched doors and a decorative side gable

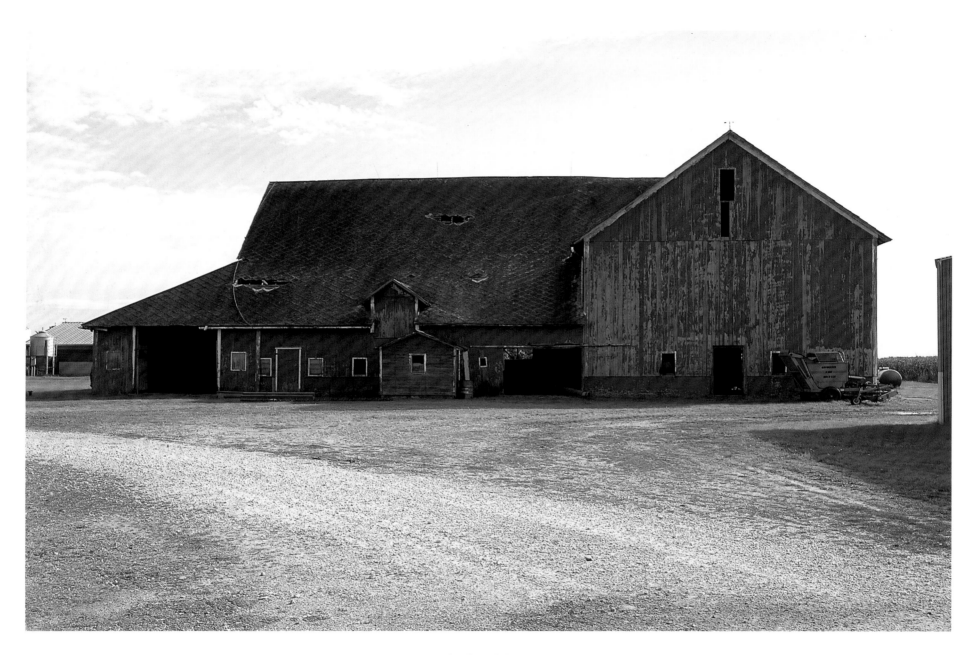

WABASH COUNTY

A three-end gable-roofed barn

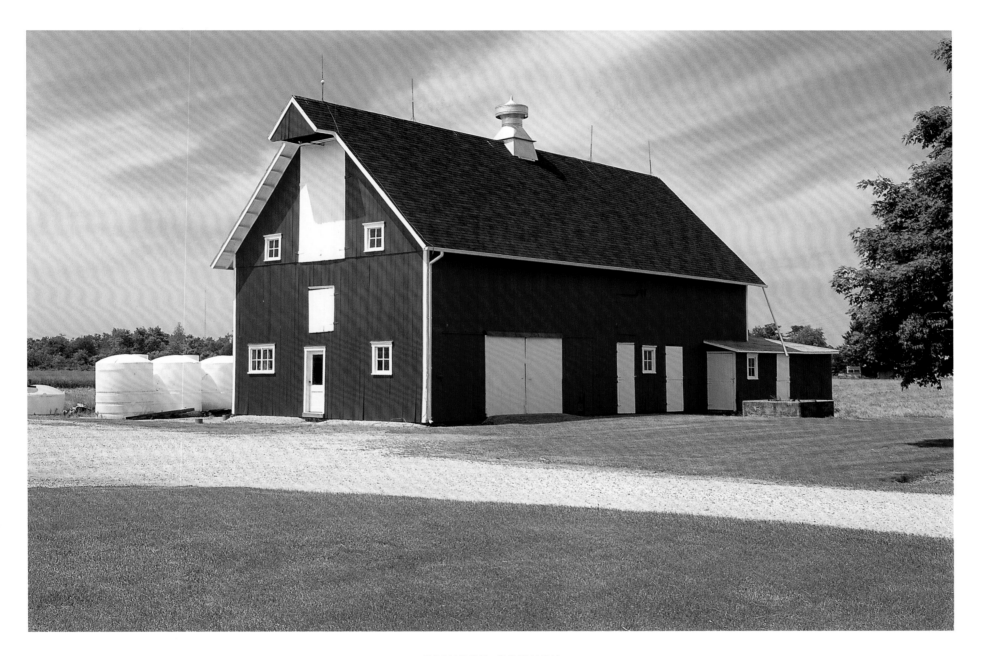

CLINTON COUNTY

*A gable-roofed English barn with a small shed-roofed addition
features a metal ventilator and a hanging gable*

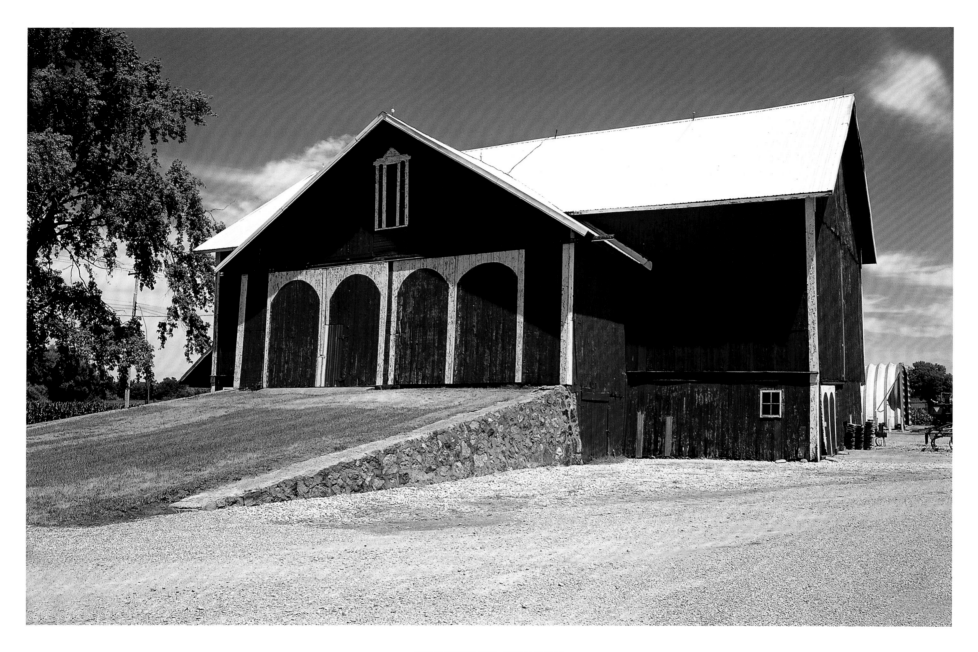

KOSCIUSKO COUNTY

*A gable-roofed, decorated English bank barn with gabled
entry porch features decoratively painted arched doors,
corner posts, and a decorated ventilator window*

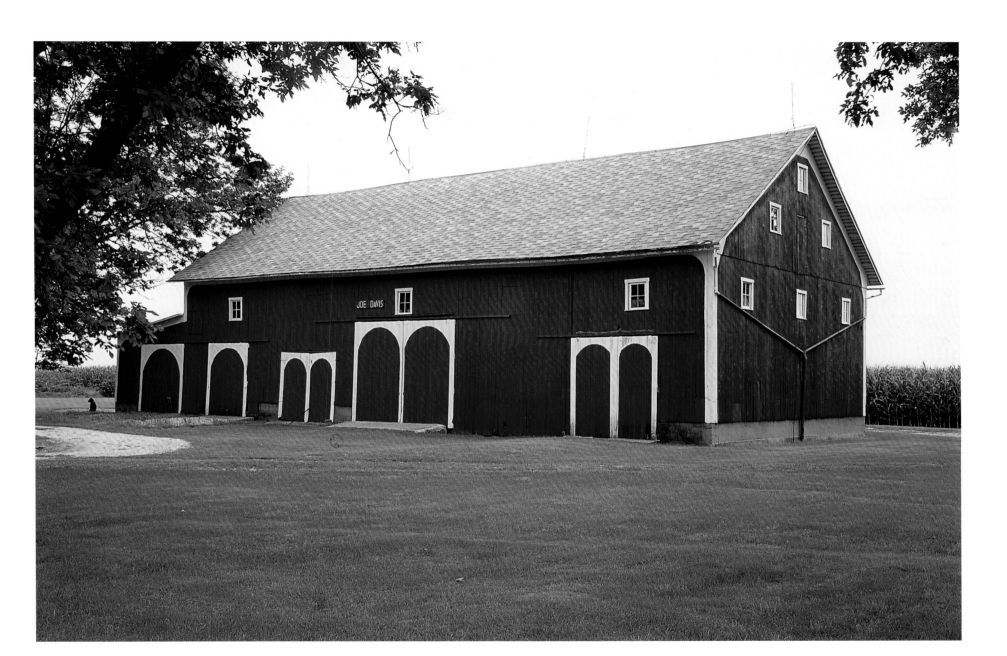

JOE DAVIS

CASS COUNTY

A gable-roofed decorated English barn with a shed-roofed
addition features decoratively painted double-arched
doors, windows, corner posts, and eave boards

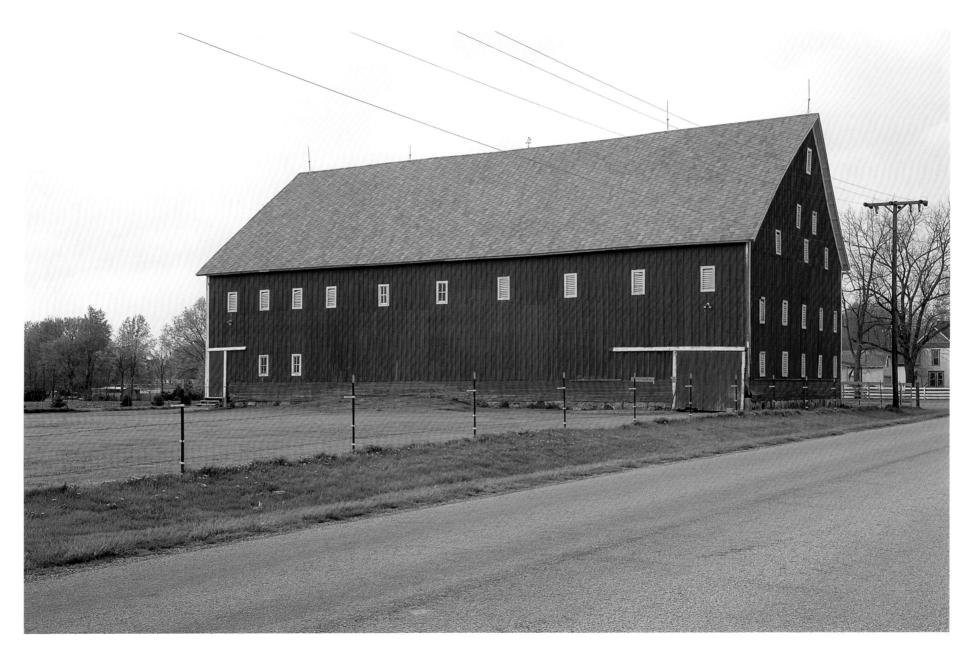

MIAMI COUNTY

*A gable-roofed English barn variation featuring
multiple louvered ventilator windows*

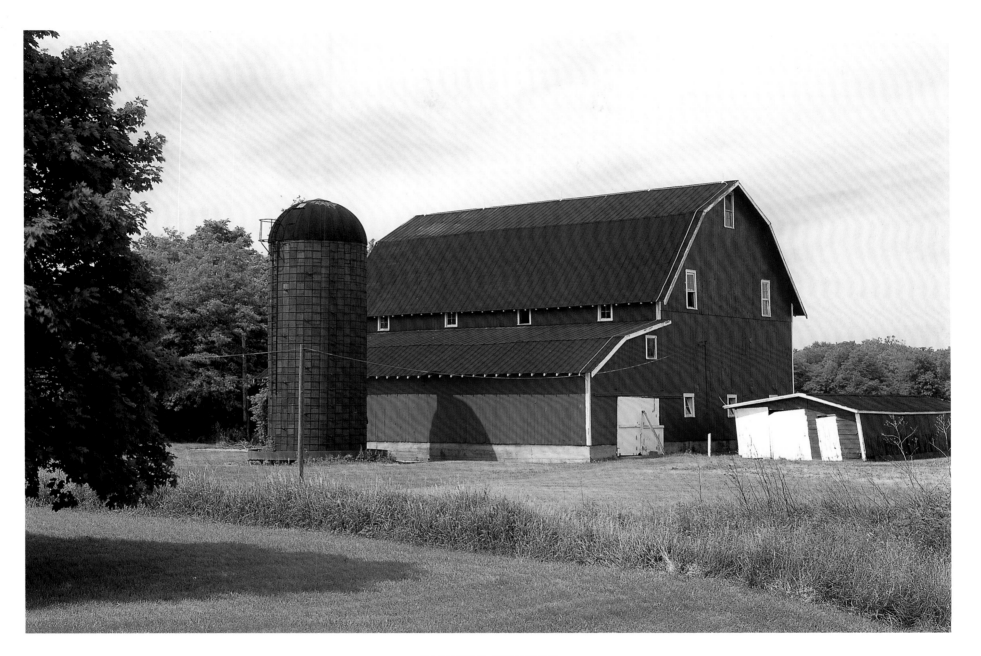

*A gambrel-roofed side-entry barn with a broken-gable
equipment shed features a concrete silo*

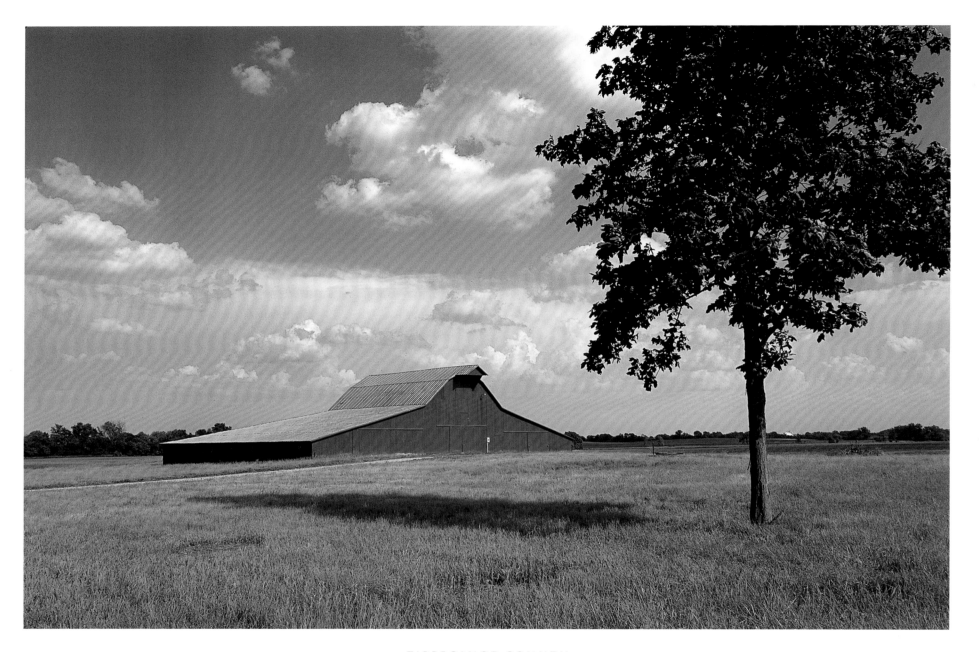

TIPPECANOE COUNTY

*A transverse frame barn with a broken-gable roof and
extended side sheds features a hanging gable*

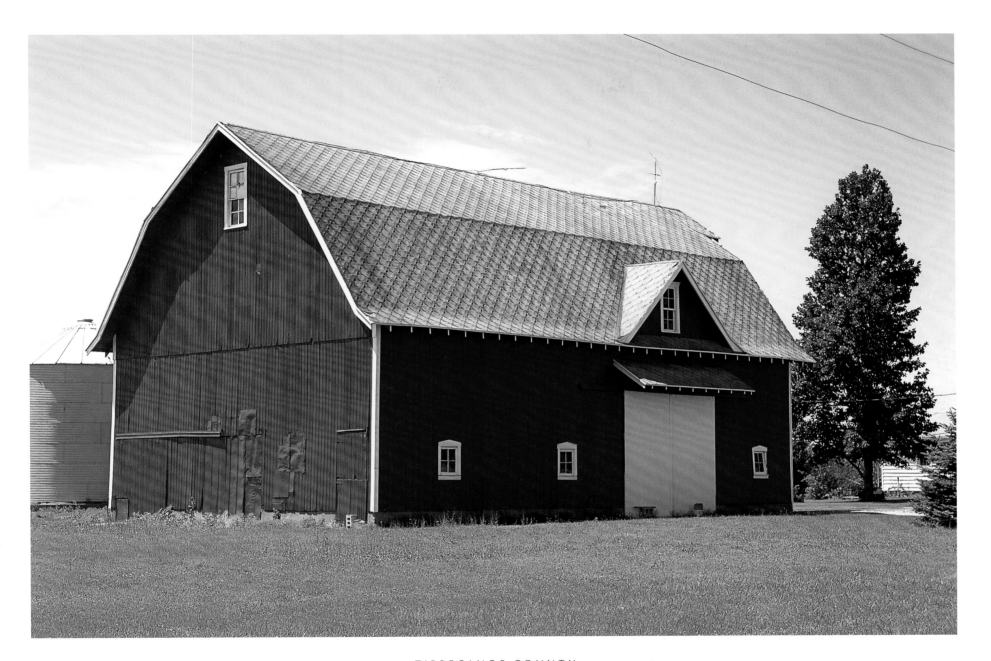

*A gambrel-roofed English barn with a pentice roof over
the side entrance features a decorative side gable*

Photo by Cathrine Spiaggia

DUNCAN CAMPBELL

Duncan Campbell retired as Associate Professor of Architecture and Director of the
Graduate Program in Historic Preservation at Ball State University's College of
Architecture and Planning. Currently, he has rejoined the Bloomington Historic
Preservation Commission as an advisory member, and is chair of the
Monroe County Historic Preservation Board of Review.

M A R S H A W I L L I A M S O N M O H R

Marsha W. Mohr has actively been taking photographs for some twenty years.
She is author of *Indiana Covered Bridges* (Indiana University Press, 2012) and
has had many of her photographs featured in publications
such as *Country* and *Farm and Ranch Living*.

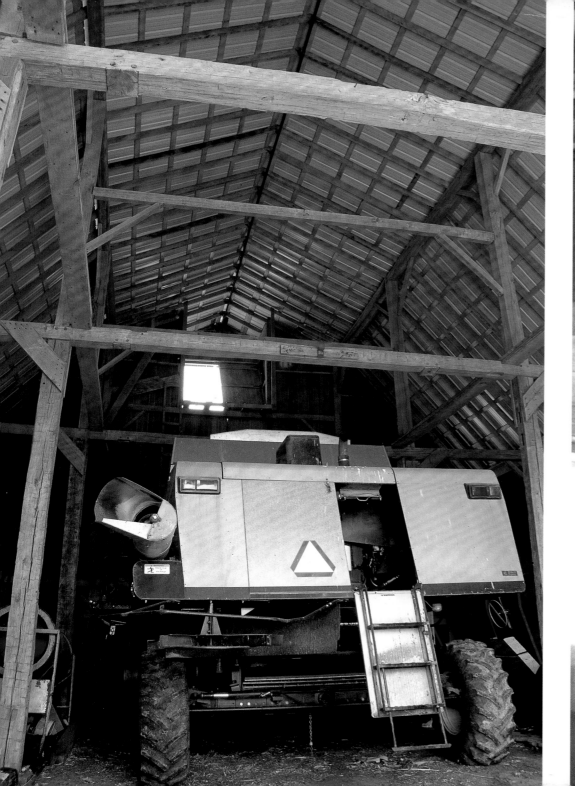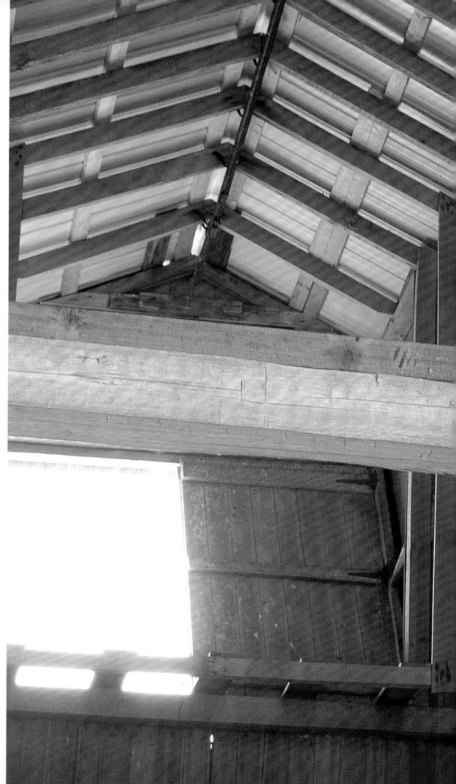

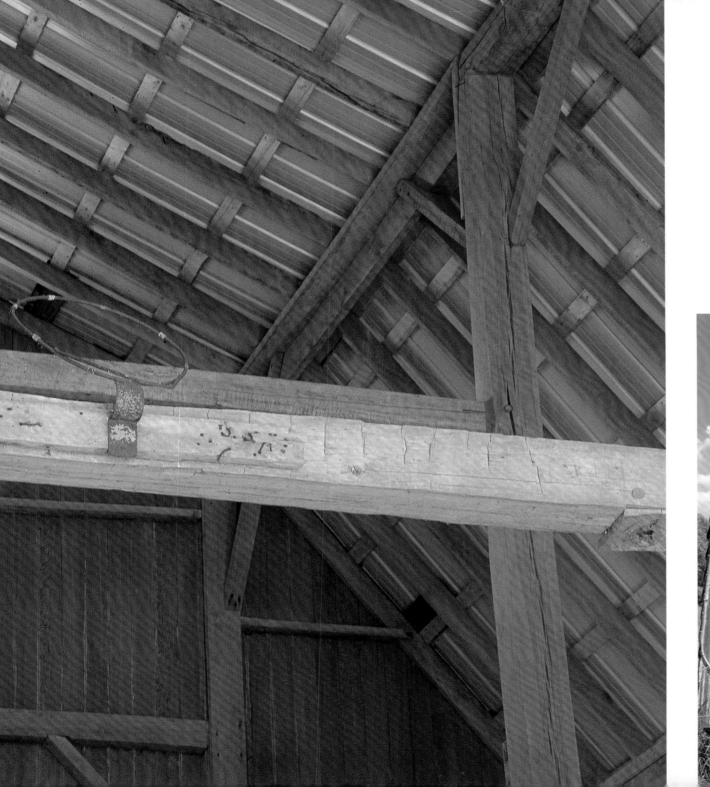